For David, chance meeting,. much valued, best wishes, Maurice. **Maurice Cockrill**

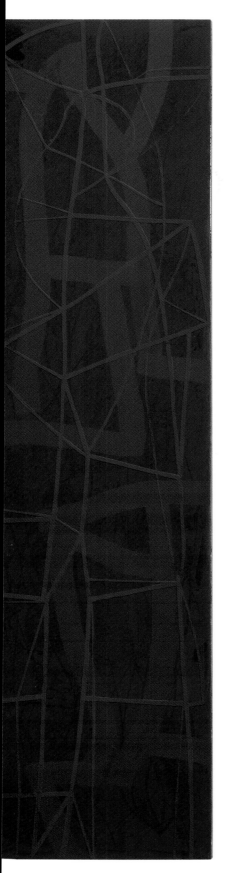
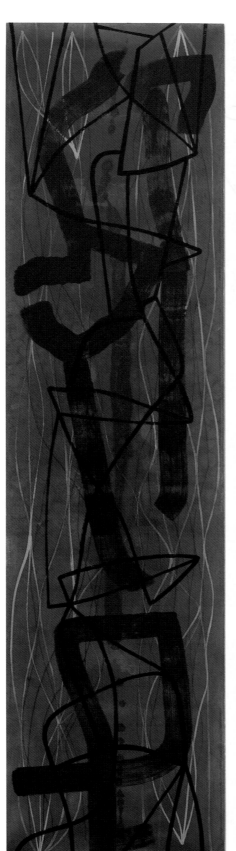
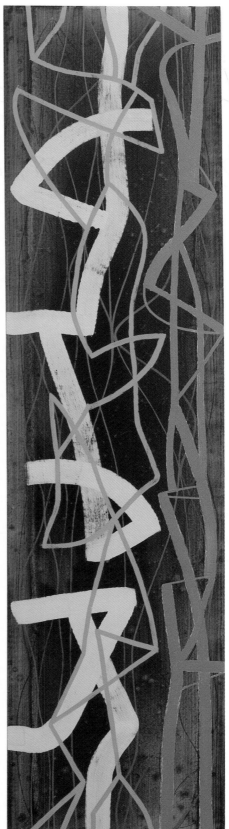

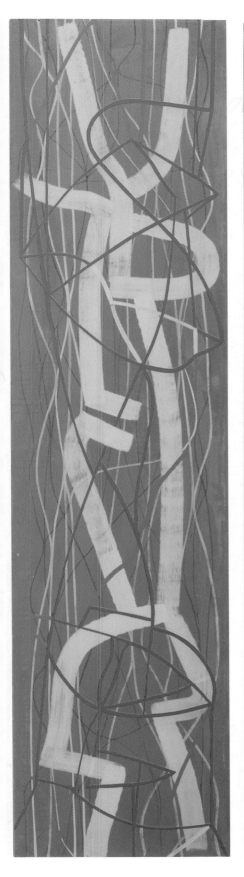

Maurice Cockrill

Marco Livingstone & Nicholas Alfrey

MERRELL

First published 2002 by
Merrell Publishers Limited
42 Southwark Street
London SE1 1UN

Telephone + 44 (0)20 7403 2047
E-mail mail@merrellpublishers.com
website www.merrellpublishers.com

Publisher Hugh Merrell
Editorial Director Julian Honer
Art Director Matt Hervey
Managing Editor Anthea Snow
Production Manager Kate Ward
Editorial and Production Assistant Emily Sanders

Distributed in the USA by Rizzoli International
Publications, Inc. through St Martin's Press,
175 Fifth Avenue, New York, New York 10010

British Library Cataloguing-in-Publication Data
Livingstone, Marco, 1952–
Maurice Cockrill
1.Cockrill, Maurice, 1936– – Criticism and interpretation
2.Painting – Great Britain
I.Title II.Alfrey, Nicholas III.Cockrill, Maurice, 1936–
759.2

ISBN 1 85894 180 6

Edited by Iain Ross
Designed by Maggi Smith

Printed and bound in Italy

Artist's acknowledgements
The artist would like to express his gratitude to
the following for their generous assistance with
the production of this book:
DZ Bank, London
Archeus Fine Art, London
Nigel Slydell
Cornhill Insurance plc
Riggs International Banking

Picture credits
Page 19: Vincent van Gogh, *Wheatfield with Crows*,
1890, The Bridgeman Art Library
Page 24: Jackson Pollock, *Portrait and a Dream*, 1953,
AKG London

Jacket *Divided #83*, 2000 (see page 109)

Frontispiece *Spectral Rivers*, 2001, oil on linen,
6 panels, each 240 × 60 cm, courtesy of the artist

Pages 124–25 The artist's studio in West Dulwich,
London, 2002, photographer: Steven Cockrill

Page 126 Portrait of the artist in his studio,
photographer: Fraser Marr

CONTENTS

Marco Livingstone

In search of synthesis

Most artists discover fairly early on what suits them – whether this be a particular medium, method, imagery, subject or style – and then proceed to elaborate, complicate or (in the most disappointing cases) do little more than repeat what they already know will work. Those conforming to this model can have their lives simplified by necessity, if they recognize their limitations and make the most of the choices available to them. Maurice Cockrill's natural facility, coupled with an almost compulsive curiosity about different and even opposing approaches to painting, conspired against him as far as finding himself was concerned. He simply had too many options and felt too strongly the possibilities of being seduced by them all. Even today he speaks of the gradual disillusionment he experiences with any one way of working, and why he changes gear when he feels he has achieved all he can in a particular idiom. The prospect of being trapped by his own history, of painting himself into a corner of his own making, repels him.

Through all these changes, Cockrill has remained stubbornly faithful to painting, which, during his working life in Britain, has been seen consistently as the poor relation, its pre-eminence threatened by one thing or another: by sculpture, by conceptual art and performance, and, more recently, by installations, as well as by photography and video. The very notion of skilfulness to which he subscribes, and which was a given condition for the making of ambitious art at least until the advent of Modernism, today counts for very little. Even now that it has become almost *de rigueur* for an artist to work in a variety of styles, Cockrill continues to find himself at odds with both the mainstream and the cutting edge because of his commitment to marks and images wrought by hand on the surface of canvas or paper. Aware as he is of the work of his contemporaries, he takes a longer view and prefers to risk heroic failure by setting his sights on the greatest achievements of the past, rather than to satisfy himself with the more easily attainable success of a limited idea endlessly mined. "The artists I've admired most, like Picasso", he explains, "are the protean ones. I'd rather be changing shape than just be doing the same thing time after time."

By his own account a late starter, Cockrill destroyed everything he had produced up to 1968, when he was already in his early thirties, and began again. The paintings for which he is now best known emerged only fifteen years after that dramatic event, following a turbulent series of new starts and abandoned investigations, and those reproduced in this monograph cover an even briefer period, from 1989 to 2002. His patience has eventually paid off. The rewards reside in the confidence of a way of working chosen over many potential directions over a long period, and they are manifested also in the richness of a vocabulary of mark-making, image-making and space-making accruing from several decades of restless investigation.

At the end of the 1970s, when he was in his early forties, Cockrill wilfully overturned the habits that he had cultivated as a painter over a period of two decades and set himself on an adventure of improvisation that has sustained him to this day. Where he had once relied on clarity of image, on direct observation, on photographic sources painstakingly replicated in an exacting linear style, he now threw in his lot with methods that were completely contrary to everything one might have imagined natural to his way of working. In an extended series of large, colourful works on paper, executed in egg tempera and pastel, he first proposed the possibility of attacking the surface with no preconceived ideas about subject-matter or imagery. Instead, he allowed the nervous energy of his hand, working so quickly that there was no time for the conscious mind to dictate, to dart across the surface, depositing marks that gradually coalesced into recognizable images. The gestural nature of the brushstrokes, with the cut and thrust of the body in movement, was shocking to anyone familiar with the restrained and calculated touch of the artist's earlier work.

The sudden arrival of this new mode suggested an affinity, and perhaps even the direct influence, of the nascent neo-Expressionism then rising to prominence among European (and especially German) painters, but Cockrill was not in search of that or any other style. Fifteen years after his move to Liverpool, he was acutely conscious of the dangers of provincialism and of the possibility of being left at the margins. His friendships with the painter Ian McKeever and the sculptor Anish Kapoor, who, as Liverpool's first artists-in-residence, had studios adjoining Cockrill's in 1980–81 and 1981–82, both inspired him with the idea that anything was possible and made him feel even more deeply his separation. The agitation and anxiety that erupted with such force in Cockrill's work at that time came not as a choice of style but out of an inner necessity, which the artist himself speaks of, with his characteristic honesty, as "a kind of desperation".

Like others in his position, Cockrill took note of developments in the world centres of art and was as aware as any painter in London, New York or Berlin of the stylistic options open to artists. However well informed he has always been of the work of other painters, past and present, the last thing he would have wanted or needed at that point was to distance himself from one movement – photorealism – only to join forces with another, particularly one that might have been regarded as its antidote. Clever and sophisticated in his outlook, but blessed (or cursed) with a sincerity that would have judged such opportunism as repugnant, he of all people would have recognized the danger of switching manners so lightly. Half a century earlier, the Dadaist Francis Picabia had spoken approvingly of the freedom to choose different styles, comparing this attitude to the nonchalance with which a man might change his shirt. For Cockrill to take such a course of action, however, would have required an ironic frame of mind totally foreign to him.

The most dramatic aspect of the turnaround in Cockrill's art around 1980 was not simply a stylistic one, but a far more disturbing question of basic principles. He had formerly dwelt on questions of perception, with trying to make sense of how things looked through the camera lens or, more subjectively, through human eyes. Now he undertook to examine how the world is experienced through all the senses: how we feel in our bodies, how we occupy space, how the appearance of the world touches on us emotionally, and how we delve into our memories of things seen and lived when confronting every new situation. Where he had once lingered on the surface of things, he sought now to strip that surface away. Even in the most achieved of his photorealist paintings, exacting in their detail and in their fidelity to the information provided through the camera's lens, and also in the still lifes and

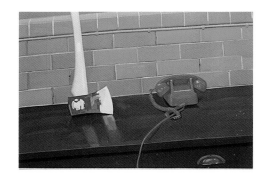

Axe and Receiver
1979, oil on canvas
914.4 x 1219.2 cm
Collection of Victor Feather, Liverpool

Night
1983, oil on canvas
245 x 153 cm
Arts Council Collection, Hayward Gallery, London

landscapes of the late 1970s, intensely rendered from life, he could go no further than the observation of the world as it presented itself to the eyes. When he began discovering his motifs through the act of painting or drawing, however, tapping into the 'psychic automatism' of the Surrealists and consequently into subconscious psychological forces, he enriched both his understanding of the nature of reality and the expressive possibilities of his art. From an essentially passive recording of the external skin of things he moved to an active reshaping of the world as recreated in the imagination and in synthesis with everything ever seen or experienced.

Years of intense looking, coupled with an intense introspective awareness of the circumstances and forces that had moulded him, played an important rôle in this shift from outside to inside, from objective statement to poetic metaphor. The figure paintings that occupied him from 1983 until about 1987, in which frequently larger-than-life human bodies were discovered through the act of painting itself, benefited greatly from the prolonged period of life drawing to which Cockrill had just devoted himself in intimate sketchbooks and other drawings made for his private consumption. Some of these sketches, revealingly, were made by looking at the model but not at the paper, resulting in a strong element of unpredictability and apparent randomness that helped free the marks from an academic servility to the motif.

The first of the new painted figures, fearsome representations of the four times of day, arrived with the dramatic suddenness of uninvited guests. Yet Cockrill had been searching consciously for a way to reintroduce the figure into his pictures, and to this end had spent much time looking at Old Master paintings in Dulwich Picture Gallery, London, and also at more modern depictions of the human form. The mythological heroines that followed, with scarred flesh and flailing limbs, appeared in such numbers and with such vehemence, like the male and female couplings that drew the series to a close under the guise of Venus and Mars, that one could imagine them to have been planned with more forethought. All these characters, however, and especially the most ferocious, entered Cockrill's pictures through the same process of finding the image through the act of painting. They were all made at a frantic pace as a way of circumventing habitual patterns of thought and laying himself open to unconscious impulses. The nakedness of the figures took them outside any specific framework of time, distancing them from comparisons with Old Master paintings but also refusing identification as specifically contemporary. They are primal, elemental and timeless, their nudity alluding to every person's condition at birth and suggesting the artist's metaphorical rebirth or reinvention of himself.

Setting aside the degree to which limbs and torsos emerged as a result of intentionality, the actual forms were unpremeditated and unpredictable. For the artist, evidently, this sense of the creator himself being surprised (and possibly even appalled) by his creations was part of the excitement. By the end of the decade the figures had exited, apparently exhausted, from his pictures, just as suddenly and unexpectedly as they had appeared. The artist explains, with disarming frankness, that he simply "couldn't find them any more". Nevertheless, there are frequent intimations of the body in the landscapes that followed and in the more abstract inventions that developed in turn from them. The painting that opens the plates section of this book, *Corona Lucis* (p. 27), synthesizes elements of three traditional categories of painting – landscape, figure and still life – with such fluidity that one would be hard-pressed to explain where one ends and another begins.

The human body may seem to have disappeared from Cockrill's paintings of the 1990s, but its presence can still be sensed. The gashes in the landscapes, which can be read in ecological terms as the

desecration of the earth by a post-industrial society, also read metaphorically as wounds piercing skin or as apertures awaiting sexual penetration. There is a sexual violence to the imagery, but also much tenderness and sensuality to compensate. This is true even of the most dramatically brutal of his pictures, such as the 1991 series 'Entrances' (pp. 44–51), which he painted over wooden doors into which he had made large, sharp-edged holes by swinging an axe. He was excited by the act of literally plunging into the surface with such a primitive tool, defacing a pristine panel and then reflecting on the constellation of marks as a kind of drawing against which to react. The door itself had connotations of the figure because of its shape, dimensions and function. The openings displayed on these surfaces inevitably arouse associations with the orifices of the body, and particularly with the vagina. Like the image of the vagina dentata used by Jackson Pollock in some of the mythological paintings that came out of his experience with Jungian psychotherapy, there is something very disturbing about these devouring and dangerous shapes, which suggest both an overpowering sexual desire and a fearfulness.

Certain passages of paint in Cockrill's landscapes remain insistently fleshy. Even the most apparently abstract recent paintings, beginning in 1996 with the series 'A Portable Kingdom' (pp. 77–85), plainly rely on the movements and rhythms of the artist's arm, wrist and hand. As such they testify to the human motivations driving their human touch. It is tempting to take even further the sense of the figure surviving against all odds. One could perhaps speak of the violent spasms with which one body of work emerges from another, in Cockrill's case, in terms of a vampiric feeding frenzy. As one entity withers or dies, so another ingests its life-blood so that the spirit is reborn, reinvigorated and transformed. This metaphor may seem a little melodramatic, but then so too are Cockrill's paintings, with their tension between beauty and desecration, and their allusions to myths, the elements, and cycles of life, death, birth and regeneration.

Cockrill has spent almost all his adult life in large cities, and the evocations of nature and the countryside in his later paintings all postdate his move to London in 1982. He describes himself as "a visitor to landscape" and admits that there is a certain element of nostalgia in his preoccupation with the subject. Of course, this is true of the origins of landscape painting as a category in itself: whether in Venice or in The Netherlands, it emerged first within essentially urban societies, and it has thus always had embedded within it an atmosphere of longing for unspoilt nature. Cockrill's landscapes are self-evident, sometimes highly theatrical, fictions that emerge, like the figures in the paintings that preceded them, from the brushstrokes and the deposits of paint on the surface. A flurry of marks turns into storm clouds; the sudden intrusion of a pale tone establishes a quality of light, or an injection of red impasto describes an opening in or injury to the earth. As with the depictions of people, however, which remain convincing as evocations of the human form whatever liberties are taken with them, so even the most avowedly synthetic landscapes strike us as true because they have been arrived at through an intense familiarity. For many years, out of the public eye, Cockrill continued to paint landscapes direct from the motif, often in North Wales, where he had spent much of his childhood from the age of six. These *plein air* paintings were occasionally exhibited, though never in London, and they have never been reproduced in the context of his main body of work. Like the life drawings, however, they have constituted not just a pleasurable activity in themselves but a return to the source and a way of continuing to educate the eye.

The ease with which Cockrill can summon forth memories of places he had seen as far back as his childhood, so that they materialize on a knife-edge between the vague and the specific, is compa-

Landfill 2
1990, oil on canvas
457.2 x 609.6 cm
Private collection, London

Ochre Machine from **'Conwy River Cycle'**
1998, oil on canvas
60 x 65 cm
Belgrave Gallery, London

rable to the way in which all of us feed visual memories into our minds while asleep. It is through this process that he achieves such a compelling, dream-like quality even in the most fragmented and abstracted of his landscapes. His accumulated visual sensations synthesized in memory provide a painterly equivalent to Wordsworth's definition of poetry as "the spontaneous overflow of powerful feelings" that "takes its origin from emotion recollected in tranquillity". Some of the landscapes have very specific references to the artist's childhood, with both happy and painful memories attached. He often played truant, wandering alone in the countryside when he was depressed or wanting to think about important issues in his life. The very thought of being in the landscape remains powerfully associated, for him, with the notion of being alone. It is consequently hardly surprising that he should have been brought even closer, through his landscape paintings, to the Romantic tradition.

The twists and turns in Cockrill's development could not have been foreseen by anyone, almost certainly not even by the artist himself. Each change of direction has been prompted by a new discovery, often investigated first in works on paper, and by a willingness to trust his intuitions. Rather than making a sudden decision about changing course, he has often allowed ideas to gestate for months or even years before deciding how to act on them. Cockrill cites his "uncertainty" as perhaps the most significant consistent trait of his ever-changing art. "Most contemporary painting is eclectic to some degree, but I'm like a jackdaw, taking this and taking that. But I still feel that in every phase there is a core that's my own. Even in the photorealist pictures. The neo-Expressionist pictures were also very particular to me, they had certain qualities."

Where others might follow the promise of consistency derived from a conventional career plan, Cockrill has preferred the excitement of making life in the studio less predictable, knowing that in any case everything will fit together when viewed with hindsight. How could it be otherwise, if the artist has left himself open to his temperament, to his aesthetic judgement and to his experiences? Defining characteristics of his persona as an artist re-emerge in unexpected ways. The importance once accorded to contour in his photorealist paintings, for instance, re-emerged totally transformed in the mid-1990s through his reliance on linear arabesques. There has been a constant dialogue, too, between surface design and intimations of depth, as well as other kinds of dichotomies: bipartite imagery, the male and female, active and passive, the organic and the geometric. None of these aspects are deliberately sought; they are simply things to which the artist has constantly returned and that strike him in retrospect as basic preoccupations.

The constant radical changes in Cockrill's painting are occasioned not by a desire for novelty for its own sake, or even less by a calculated bid to feed the art market, but by a need to keep fresh for himself the very act of producing art. By maintaining himself constantly off-balance, he finds a way of 'making it new' every time he enters the studio. The sinuous curves that dart across the paintings of the four elements that he made in 1998, vibrating and pulsating into imaginary depths, retracing their paths but never following the same route twice, perhaps tell the story better and with more subtlety than one ever could in words. In their apparently unpredictable but always confident paths, they present themselves perfectly as a subconscious metaphor for the trajectories of the artist's evolution.

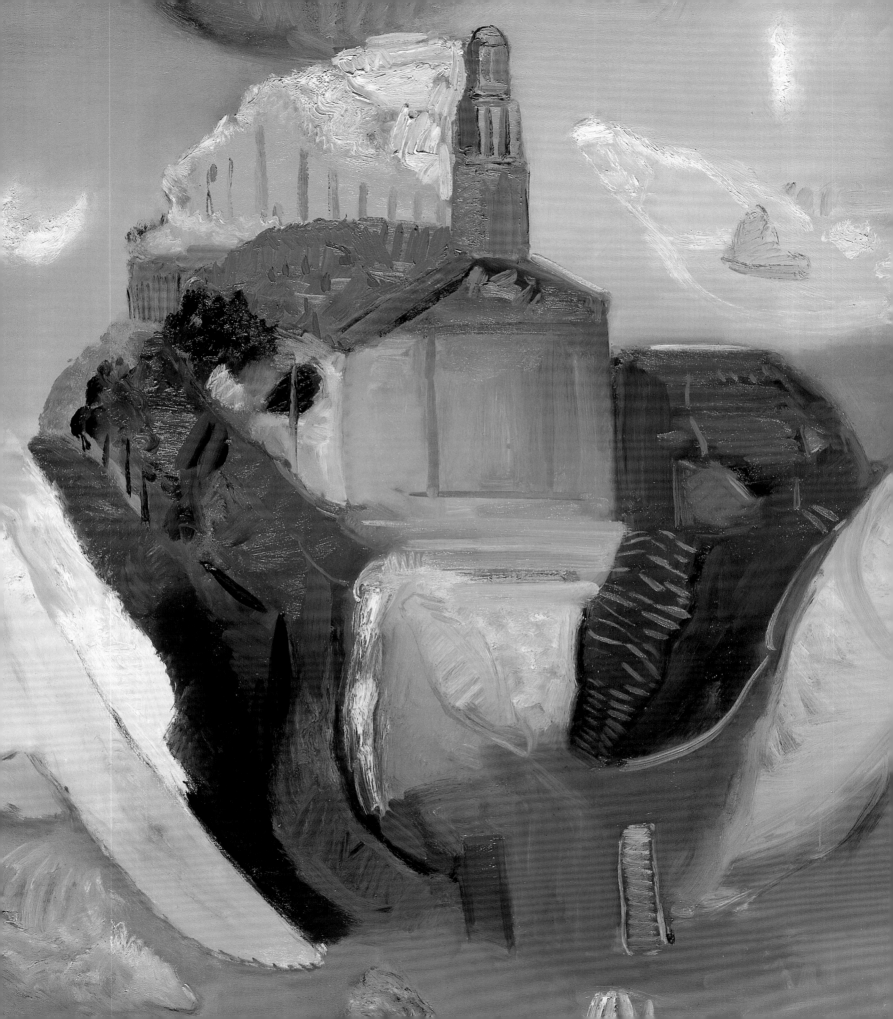

Nicholas Alfrey **Maurice Cockrill: The elements of painting**

Corona Lucis (detail, p. 27)
1988–89, oil on canvas
203 x 178 cm
Bernard Jacobson Gallery, London

The paintings and drawings illustrated in this book are a selection from the remarkable body of work Maurice Cockrill has produced over the last fourteen years. A series of meditations on the themes of memory and generation, the processes of growth and wastage, and the relationship between dynamic and destructive forces is developed through a succession of interlocking cycles and groups of work. Each phase engages with specific, strongly defined formal concerns, but taken together the separate episodes combine to make up a coherent visual system, informed by a consistent philosophy. This essay aims to demonstrate the compelling internal logic of the work of these years.

The sequence of paintings begins in 1989, when Cockrill was already a seasoned painter with a reputation among fellow artists for his seriousness, dedication and ambition. He was also sometimes thought of as an eclectic and unpredictable artist, someone who had successively reinvented himself – as an urban realist, an expressionist, a painter of violent mythology and lyrical landscape. In several of these manifestations, Cockrill had certainly given ample proof that he could take his painting to a pitch of memorable, and sometimes searing, intensity; what was less apparent was how these episodes might be connected, or even how one might distinguish a coherent authorial position.

When, in 1995, the Walker Art Gallery, Liverpool, held a retrospective of Cockrill's work of the previous twenty years, the dominant impression conveyed might still have been one of restless diversity, accentuated, if anything, by the most recent paintings to be included, which seemed to be edging towards a kind of organic abstraction. The sheer range of the work on show would have been hard to match in the output of any of his contemporaries, but eclecticism as a principle was never the driving force behind it. A closer look would have revealed that there were recurring themes and formal strategies underpinning the work, and that running through it was a developing personal vocabulary of symbolic forms and characteristic painterly devices. The interconnectedness of ideas, motifs and gestures had already begun to emerge clearly by the last stages of the Liverpool exhibition, and has become steadily more marked in the years since.

The painting that, more than any other, figured as a turning point in the Liverpool exhibition also opens the sequence of images in this book. *Corona Lucis* (p. 27) not only displays a changed method of painting – it is more lyrical in its handling than the turbulent, fractured landscapes that had immediately preceded it – but also, in making London its explicit subject, it takes up the idea of a great city as an energizing and consuming organism, and also serves as a symbolic marker of the artist's own place in that city. Both the forms and themes of the painting prefigure a number of significant aspects of the works that follow.

The central motif is the portico and tower of St Luke's Church, West Norwood, the district in which Cockrill had settled seven years earlier. This is hardly a straight exercise in urban topography, however; the church and a few residual elements of its surrounding environment are floated against a subaqueous landscape in which various fossil or shell-like forms also seem to be embedded, all irradiated by the mysterious 'crown of light' of the title. The overall configuration, in which earthy, matter-like elements form a centrally placed cluster, surrounded by a more open or liquid field, bears a striking similarity to the 'Generation' series of 1993 (pp. 58–65), while the suggestion of the spread female body in *Corona Lucis* seems further to strengthen the connection, conveying the unmistakable idea of a generative force. The imagery of new growth will be a recurring one throughout Cockrill's work (it is the title of one of the paintings in the 'Wheat' series, for example): here, the city is fantasized as a site of fertility in a painting completed in the year that the artist's son William was born.

But the web of association spreading out from this painting is still more complex, and tracing it out will help to illuminate some of the ways in which Cockrill's personal experience continues to intersect with different registers of history. He has always been acutely conscious of a sense of place, and the association of other artists with a particular location, or their passage through it. He knew that St Luke's had been painted by Pissarro, for example, and the presence of this other artist–outsider helped him to negotiate his own creative terms with his environment. But he is also responsive to the larger historical resonances of London's sites and monuments. He was aware that St Luke's was one of four churches named after the Evangelists to be built in the new south London suburbs to commemorate the Battle of Waterloo, and the idea of the threads connecting the perceptions of an individual and a newcomer to the centres of power and history resurfaces a few years later in the series 'A Portable Kingdom'. This series had its origins in a glimpse of Nelson's Column in Trafalgar Square, that over-familiar memorial to another great Napoleonic battle, suddenly made poignant for him by a double memory, one recent, one remote. Cockrill's recent visit to Australia had made him vividly aware of the sheer extent of that empire of which the symbolic centre was Trafalgar Square, of the energy needed to gain it and sustain it, but also of its ephemeral nature, and of how it ultimately had faded away during his own lifetime. The other, distant memory was of himself as a young runaway, drawn to the heart of London and the National Gallery (always one of the symbolic centres of his own world), and sleeping rough on a bench near the column. Again, the example of an artistic precursor helped to shape his own response: Mondrian's painting *Trafalgar Square*, begun in London but still unfinished at the time of his departure for New York in 1942, a beginning and unresolved ending marking in themselves a shift of power from one centre to another.

All Cockrill's work is informed at some level by his awareness of cycles of dominance and influence, of movements of energy, creativity and dispersal. But these general ideas are expressed only through the particular means of painting, and the complex play of imagery and association in his work cannot be considered apart from the question of formal procedures or his rigorous exploration of the potential of his chosen materials and tools. It is an approach that combines a deep awareness of the wider concerns of modern painting with his own intense experiences of the world.

The three sections that follow explore the close meshing of practice, memory, ideas and association that characterizes Cockrill's work. The arrangement follows a broadly chronological order, but there is some thematic overlapping; the artist's development has not been a strictly linear progress, and there is a pattern of links, echoes and returns running beneath the main sequence that needs to be

brought out. The central section of the three is the longest, and is concerned with the unfolding sequence of groups and cycles from 'Song of the Earth' to the 'Elements'; this sequence makes up the backbone of Cockrill's painting over a ten-year period, and all the work within it can be understood as a series of reflections on the processes of nature, conceived variously in relation to human intervention or at a more abstract level. This section is flanked by two shorter ones; both touch on the significance of particular landscapes for his work, and both focus on the symbolic representation of one of the elements, first fire, then water. The first section looks at the troubled landscape around Brymbo in North Wales, where the artist spent his childhood, and at the City of London: both are seen as places shaped by fire. The relationship between the two episodes implies a creative trajectory that moves from province to capital, memory to history and experience to imagination. The third section addresses the theme of the river in his most recent work, and shows how sustained observation of one particular river, the Conwy, leads to the idea of a river as a symbolic system, analogous to the phases of human life. The section also looks at two related groups, the abstracted 'Divided' series, concerned with the principle of difference and opposition, and the most recent 'Bridge' paintings, in which the natural elements are bound in a clear pictorial order.

Places of Fire

By 1989 the paintings Cockrill was making were all recognizably within a landscape idiom (pp. 29, 31). He had established a place for himself in the city, and his recent one-man exhibitions in London and Germany had gained him a reputation as an artist willing to take on the challenge of the great tradition of European figure painting. But now landscape had progressed from being the invented background to some mythological scene to become a compelling subject in its own right. And these new landscapes were no longer unspecific locations, but were informed at a deep level by memories of the industrial margins of North Wales, which the artist had known as a child.

Cockrill moved to North Wales in 1942, when he was six years old. His father, an itinerant construction engineer, had come to work on a new rolling mill at the steelworks at Brymbo, near Wrexham. The area had been one of the cradles of the early Industrial Revolution, and its coal and ironstone deposits meant that it continued to develop; the steelworks itself was at the hub of a complex network of tracks, pits, quarries and workshops, a dynamic force ceaselessly obliterating its own history. The land in the immediate vicinity was broken and ravaged, but just to the west rose the long shoulder of Minera Mountain, and beyond this the unsullied uplands and secluded wooded valleys stretched away to World's End and Llangollen. The whole area presented a classic boyhood playground, and this is how Cockrill recalls it in his *Fragments of Autobiography*, first published in 1992: "Endless seasons – haymaking, bird-nesting, rambling and climbing among woods, magnificent beeches, oaks, rummaging for bits of Sten gun in the scrap wagons, the abandoned mansion with its mysteries and terrors, tunnel of yews, owls, dread of school … ." It was a half-rural, half-contaminated domain, full of secret, thrilling, sinister and dangerous places. It is the source of much of the intense and apparently fantastic imagery that, after a gap of forty years, had worked its way back to the surface and become the stuff of painting.

This is in no sense a retreat into nostalgia, however, since this is a landscape disturbed in more ways than one, and a place in which absolutely nothing remains fixed, no memory unequivocal. For years, the Cockrill family themselves had no proper home to call their own, but lived in rented rooms

Railway fragment at Lodge, North Wales

while Cockrill's father had moved on to work on other sites further afield. (Later, an aphorism from Gaston Bachelard's *The Poetics of Space* seemed, for Cockrill, to confer a retrospective significance on the rootless existence of these years: "It is better to live in a state of impermanence than in one of finality.") The village that was their provisional home was called Lodge, after its proximity to Brymbo Hall, a Jacobean house once regarded as one of the handsomest in Wales. It was now the "abandoned mansion" of the artist's memoir, housing only chicken-feed and farming gear, and he and his friends would dare one another to climb up to its reputedly haunted attics or to spend the afternoons smashing crockery left behind by the army in the boarded-up basement kitchens. Later, the house itself would be swallowed up by open-cast mining, its own venerable history overtaken by the insatiable requirements of industry. But the village of Lodge itself was scarcely more secure, since it lay in the shadow of the huge, relentlessly advancing bank of slag that was being continually extruded by the works, and that would eventually obliterate the place entirely. Finally the whole steelworks would be closed down, and everything within its perimeter dismantled and sold off, leaving only a melancholy, post-industrial wasteland. So the fires that had for more than two centuries created wealth and life here, as well as environmental chaos, were themselves extinguished by implacable economic forces, and a whole community blighted.

Brymbo is therefore a difficult place to return to, and Lodge, somewhere at the heart of this shape-shifting landscape, is literally impossible to revisit. Besides, carefree boyhood explorations apart, the personal associations the place came to hold for Cockrill were increasingly disturbing and unwelcome. To reflect on the significance of this landscape is really possible only through the means of painting. The motifs and symbols in the paintings – the shafts and chimneys, thickets and residual copses, concealed chambers and enigmatic detritus, and of course the sudden incursions of fire – are markers of far more than just the artist's intense childhood engagement with an extraordinary, unstable and unrecoverable domain. The experience of Lodge and Brymbo is made to stand for wider cycles of exploitation and exhaustion, and renewal too, since that has been possible here through the act of painting, and might still come about on the scarred ground itself.

'Place of Fire' becomes the collective title for a new series of works on the theme of fire begun a few years later, in the autumn of 1994. The first of them, *The Golden Boy of Pye Corner* (p. 66), makes

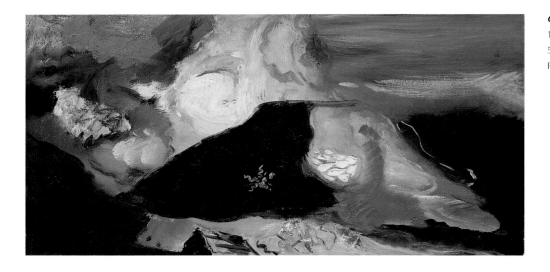

Cradle
1989, oil on canvas
50.25 x 101 cm
Private collection, London

a specific allusion to the Great Fire of London of 1666 (the emblem of a golden boy on a building near Smithfield Market marks the spot where the fire is said to have come to an end). The idea, therefore, is of fire as an active agent in the formative myth of the city, purging the old and plague-ridden, making possible the creation of a new order. But though the reference is to a historical conflagration, it is clear that the real interest of the theme for the artist is in the 'place of fire' in our lives generally, and that the idea is still rooted in his own memories: his bedroom glowing red at night as the slag was spilt down the bank from the steelworks, his mother cooking supper on an open fire. In notes written on the occasion of his 1997 exhibitions at the Galerie Clivages, Paris, Cockrill reflected that

> in the relatively short space of this life, fire as a force, as an intimate visible presence in our lives ... has largely disappeared. We learn of the fires of disaster but we no longer, as Canetti believed, "keep fire in a box and feed it like an animal" ... Fire warms, purges, harms, illuminates. Gone from the hearth, its insatiable nature feeds my work still.

The containment of fire is a sign of progress, but for Cockrill the element remains one of the fundamental agents of change or mutability.

All the paintings in the group have the same format, two tall juxtaposed wood panels covered in canvas, painted separately, the left side dark, the right illuminated. The effect is of double doors (there is an obvious reference to the earlier series 'Entrances'), or perhaps of an opened-out book, showing one page of exhaustion, the other of incandescence.

The Golden Boy of Pye Corner, appropriately, has visual qualities redolent of the Baroque, the sumptuous London that will emerge, phoenix-like, from the blaze: the swelling form of the silhouetted boy, the red and black laid over gold, the suggestion of garlands and wreathes whirling upwards. In other works in the group (pp. 67–69), the imagery is not historically loaded, or even urban, though winged embers momentarily resemble charred street plans swept up by the heat. Across the two panels, forms are discontinuous, sometimes sheared off but occasionally creating a subliminal echo: consumed, thorny branches and scorched traces are inscribed on the left, while on the right fecund shapes and living blooms can be made out, paradoxically on the side of fire.

Natural Histories
The long series of interlinked groups of paintings that stretches from 'Song of the Earth' of 1989–90 to the 'Elements' of 1998 can be understood as the progressive development of a system of forms and symbols capable of expressing the processes of nature. The overall tendency of the sequence considered as a whole is clearly towards abstraction, and this can be demonstrated by a comparison of the early 'Four Seasons' (pp. 40–43) with the later 'Four Elements' (pp. 94–99). In the former, the idiom is still recognizably that of landscape, with inflections even from British neo-Romanticism and the work of Nash and Sutherland, whereas in the 'Elements' the forms are less specific and the frame of reference is oriented to the great models of European and American Modernism. The 'Seasons' are atmospheric and spatially ambiguous, whereas the 'Elements' display a consistent all-over structure; while the 'Seasons' are full of idiosyncratic pieces of painterly business, the 'Elements' are more disciplined and tend towards the dispassionate and hard-edged.

The evolution of the sequence as a whole involves a succession of revisions of the place and character of the painterly gesture, driven in part by Cockrill's suspicion of his own technical facility

and his ability to create an immediately recognizable individual world in paint, both obvious from the outset. Certainly the paintings at the end of the sequence are more austere in character, and less discursive in approach. At the same time, structure, drawing and painting become progressively more closely integrated, so that the meaning of a painting is increasingly bound up with the way in which it has been made. Each group engages with a clearly defined set of formal issues, so that each phase has a strong visual identity of its own. But while there may be a clear logic running through the sequence as a whole, the relation between individual episodes is complex, and a wide variety of different scales, formats and surfaces is deployed within any given phase.

The group of landscape paintings associated with 'Song of the Earth' (pp. 28, 30–32, 34) was exhibited at Bernard Jacobson's gallery in London in March 1990. These paintings have already been characterized in the preceding section as an imaginative revisiting of the landscapes he had known intimately as a child, made in the knowledge, too, that this was a journey that could no longer be made in reality. But the paintings in this group are not conceived literally as regional landscapes, as the title, with its allusion to Mahler's song cycle *Das Lied von der Erde*, makes clear. The visual references are also wide-ranging, with a number of paintings adapting the double-square format chosen by Van Gogh for some of the last paintings he made at Auvers, and it is evident that Cockrill wishes to measure himself against the standard of the classics. Throughout the group, the imagery is consistent in its focus on the exploitative relations between man and the natural environment, but the emphasis is on nature's infinite capacity for recuperation; the landscapes may be broken and abused, but signs of the healing process are everywhere apparent.

The 'Four Seasons' were the major enterprise of 1990. At first sight they may look like a grand summing up of the preceding pictures, but there are crucial differences of emphasis in imagery and structure, and Cockrill certainly conceived of them more as a new beginning than a reprise of what had already been achieved. It is true that a number of motifs and devices had appeared in the earlier landscapes, but there are no signs of man's destructive interventions here, and nature's processes are presented as a timeless cycle of renewal, flowering and decay. The initial intention was to work on circular canvases that would embody the idea of nature having no beginning or end. The oval form eventually chosen is half-way between a rectangle and a circle, and expresses symbolically the elliptical trajectory of the Earth around the Sun. The overall effect is strongly decorative, as if the paintings were meant for some yet-to-be-realized pavilion or imaginary garden room. All the paintings could still be described as being in the idiom of landscape, but as the cycle progressed the forms became increasingly abstracted. *Winter* was the first to be painted and still has the clearest horizon line. At the bottom, beneath the surface of the barren land, lies a sediment of the primary colours, suggestive of the analogy between the latent stuff of new life, dormant at present but awaiting the moment of resurgence, and the raw materials of painting itself. *Summer* and *Autumn* were each painted fluently in their own season, but Cockrill had difficulties with *Spring* that were resolved only by making a new beginning on a fresh canvas and then letting everything flow out from a great swathe of black. So *Spring* is the most radical compositionally: the horizon is attenuated and drawn inwards, and with hindsight the whole painting no longer looks like a landscape, but anticipates the floating, centrally placed forms of the 'Generation' series.

After the grandly conceived, elegantly made 'Seasons', Cockrill chose to make his next series of paintings on cheap, mass-produced doors, sanding off their original lacquer and adding a sealant of

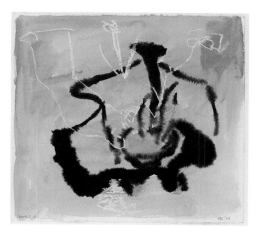

Studies for 'Generation', 1 and 2
1993, watercolour on paper
25 x 28 cm
Galerie Clivages, Paris

his own (pp. 44–51). They are 'found objects', offering the artist both the resistant surface he was looking for and a rich, ready-made field of association, since a door will inevitably imply the presence of the human figure and is tailored to the human scale. In spite of these obvious implications, however, Cockrill treated his 'Entrances' very much as landscapes, revealing them in depth as through a cross-section, winding the forms down from the top, like a river map, or arranging them in the configuration of a sheaf, plant or tree. *The River* (p. 46) was the first of the set to be painted; in the subsequent nine pieces, the drawing was done with the blade of an axe making a pattern of controlled incisions, and using as an instrument of creation something more normally associated with sundering and violent action. The resulting disruptions are like literal versions of the shafts, rakes and adits that cut into so many of Cockrill's recent landscapes, but here the painter's mark is intended to signify the release of a sudden transforming energy at the surface.

The 'Wheat' series of 1992 (pp. 52–57) is a return to one of the most traditional subjects in the Western repertoire, and a turning back to the idea of the seasons too, since the representation of summer and that of harvest are inevitably linked. Cockrill was fully aware of the richness of the cultural legacy of the theme of wheat, and of the significance of grain at so many levels of history and representation. But could it still be made the subject of a convincing painting? In the end it was, again, the example of Van Gogh that provided a starting-point. He had already made allusion to such late double-square compositions as *Wheatfield with Crows* in his 'Song of the Earth' phase, and now the same picture became the basis of another homage, in three large paintings that took up Van Gogh's motif of three branching paths. Colour became another means of establishing an underlying structure, and the three paintings were each organized around one of the primary colours, combined with its complementary; this is seen in its most highly charged aspect in the yellow and violet of *Wheat: Three Paths #3*. Other versions of the theme, such as *Wheat: In the Lane* and *Wheat: Insemination*, are striking for the towering form that looms suddenly above the fields, and that in a double swirl seems to disclose a succession of motifs, bold but on an uncertain scale – grain, husk, an ear of wheat, a fold of earth. This enigmatic sign writing seems to lead directly to the paintings of the next series.

The paintings collectively titled 'Generation' were among the most ambitious and daring that Cockrill had yet produced, in scale, scope and method. The initial, exploratory stages took place in 1993, in his studio in Cambridge Gate, London; then came a move to a new studio nearby in the

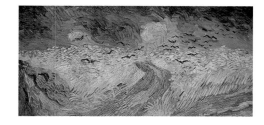

VINCENT VAN GOGH
Wheatfield with Crows
1890, oil on canvas
50.5 x 100.5 cm

19

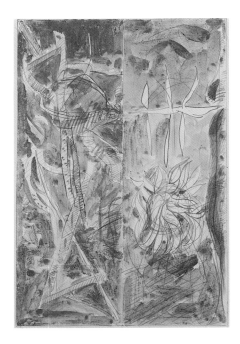
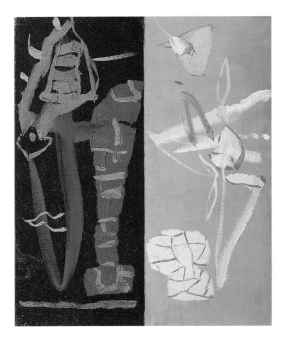

Study for 'Ash', 4
1995, pencil, wood ash and gum arabic
33.5 x 22 cm
Courtesy of the artist

Ash #9
1995, oil on canvas
508 x 406.4 cm
Private collection, Paris

dilapidated building that once housed Daguerre's Diorama in Regent's Park, and the breakthrough into a new and distinctively economical way of working. The nine large paintings at the core of the group were achieved remarkably quickly, and the whole series was substantially completed early in the following year. The new paintings no longer have any visual relation to landscape, but they continue to deal with the conditions that make life possible. In these works, it is as if the artist is staging his own primitive drama of creation.

There are three basic visual elements in the paintings. The first is the coloured ground, laid down as an unbroken field of scarlet, blue, yellow, grey and so on. By asserting the primacy of colour in this way, Cockrill is aligning himself with one of the principal concerns of twentieth-century art, and doing so in a way that he had only hinted at before in his work, in the dormant primaries of *Winter*, for example, or the schematic colour oppositions of the three large 'Wheat' paintings. Subtle modulations in the coloured void then determine the form of the second element, the central mass of apparently inert matter. This has a strongly sculptural character, and indeed was partly suggested by sculpture of a kind: the crudely moulded clay 'base' in which ash sticks had been embedded that he had been spontaneously moved to make from materials to hand in his south London garden with his young son. The third element is the more complex and calligraphic part, the long hooks, stirrups and strands of paint that emerge from the opened-up central mass, together with the various other forms issuing from the material core.

The paintings give visual shape to the idea of the origin of living forms, and as such take their place in a sequence of meditations on fecundity that goes back to the 'Song of the Earth'; each successive phase of these meditations seems to be cast in progressively abstracted and remote terms. But the idea of generation has a personal resonance too; the paintings also work as private allegories, made in the consciousness of the interval of a whole generation separating his youngest son from his two elder, and of a cycle beginning again, and of this new life coinciding with his own renewal as an artist.

Finally it is the pared-down procedure that makes the series seem pivotal in Cockrill's œuvre. The artist has begun to realize an ideal here in which every gesture is made to tell, and every aspect of the making process registers clearly on the surface. It is an approach that is both methodical and improvised, eloquent and makeshift, leading to an exultant revelation of a world that only paint can generate.

The 'Place of Fire' series (pp. 66–69) followed 'Generation'; the first diptych was made in the autumn of 1994, in time for inclusion in the catalogue of his retrospective exhibition, and a larger group was exhibited at Bernard Jacobson's gallery in February 1995 to coincide with the opening of the Liverpool show. Glamorous, almost heraldic in its strong opposition of black and red, the series as it evolves deals less with the apocalyptic transformation of cities in history than with natural changes of state. The series was followed, with narrative logic, by the 'Ash' paintings (pp. 70–75). In fact *Ash* had already been chosen as the title of one of the large 'Generation' paintings, the one on a grey ground (pl. 61); a glowing ember lies at the heart of the dark central core, and delicate tongues of flame adhere to one of the emerging skeins of paint, but despite this burning imagery the painting is perhaps the calmest and most beautiful in the entire group. It seems clear from this that Cockrill thinks of ash as a soft, nurturing, benign element, not simply consumed matter but the basis for future growth. The new paintings maintain the two-part surface of their predecessors, although they are not literally diptychs, but canvases divided vertically into two zones, one dark, the other grey. The chromatic note is notably more restrained than the work of the previous months, and the imagery is strongly reminiscent of Philip Guston, with its ladders and walls, charred sticks and thorns, pennants and pale flames.

On the face of it, the 'Portable Kingdom' paintings (pp. 77–85) that came next are out of place in a section devoted to 'natural histories', since they are concerned with culture, history and states of mind rather than with natural elements. But in many ways they are a logical extension of the previous two series, both formally, in the idea of a divided field, and thematically, in their concern with the ways in which a powerful entity can be dissolved and altered. The series began after Cockrill's return from a visit to Australia in the autumn of 1995; the phrase 'portable kingdom' came from Heine by way of Bruce Chatwin's *The Songlines*, and refers to the idea that we carry our homeland with us in our hearts, and that it is not to be located in any secure or stable physical domain. To an artist whose own home country was itself so provisional, its physical contours continually re-formed, and his village erased from the map altogether, this is obviously going to be a poignant notion, but added to it is the larger idea of the dissolution of empire, the disintegration of a world order.

The motif of the square is at the heart of the series, which began with a large number of drawings, some of the earliest based on Trafalgar Square itself, a square divided by a column. Then came

Untitled
1996, gesso and ink on
handmade paper
20 × 40 cm
Private collections, Paris

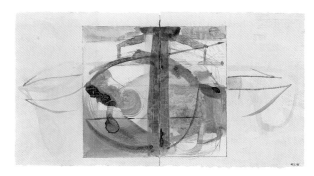

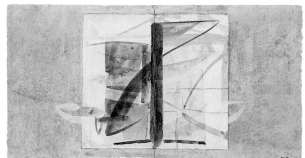

small paintings in tempera on a gesso ground, until the scale became gradually enlarged, in the case of paintings such as *Land of Nod* (p. 77) and *Scarlet Progress* (p. 85) attaining a wide, panoramic format without precedent in Cockrill's art. All the work in the series deals with the relation, formal and symbolic, between a centrally placed square or enclosure and the wider field beyond it. A network of branching and intersecting tracks extends across the whole field, emanating from the central square or passing through it. The square could be read as a repository of energy, charging the entire field with its influence, or, more ambiguously, as a defended enclave, a space increasingly breached, penetrated and diminished. Forms outside the square sometimes appear less substantial, like ghostly versions of those in the centre; elsewhere, values are reversed, as in the grave dark/light counterchange of *Next Last Walk* (p. 78). In the panoramic canvases especially, the prevalence of the black square seems less certain than the flow and exchange of open traces surging all around it. The appearance of the strong red primaries in *Heart* (p. 80) and *Scarlet Progress* reinforces the presence of Mondrian as a guiding spirit here (his own *Trafalgar Square* had, after all, been Cockrill's specific point of departure); this is a world tending more towards disintegration than the realization of Utopia, however, though painting still holds out the possibility of a projection of harmony.

The all-over interlacing mesh of linear elements continues in the 'Dilation' series of 1997 (pp. 86–93), but instead of a geometrical device holding the centre, a nebulous, vaguely cruciform shape is placed symmetrically on the coloured ground. The effect is like that of an after-image, a blur of colour that hovers behind closed eyes. The 'dilation' of the title alludes directly to the action of the eye itself, the way the pupil enlarges in response to a visual stimulus. There is a certain tension between the complex web of signs across the visual field (perhaps significantly, the other meaning of 'dilate' is to relate at length, to discourse) and the coloured pulse one senses expanding beyond. A further complexity is introduced in certain canvases, such as *Black Lane* or *Magnus 1* and *Magnus 4: Red Rain*, that feature a central shower of red tears, flames or drops of blood. This motif derives from a painting in the National Gallery, London, by Lucas Cranach the Elder of Johann Friedrich the Magnanimous, the young heir to the Electorship of Saxony, in which the beautiful boy's green garment is ornamentally slashed to reveal glimpses of red underlining. The unexpected conjunction of abstract principle and sensuous physical detail is entirely characteristic of the artist.

In 1998 Cockrill embarked on another of those grand thematic summaries that occur at intervals throughout his career: after the 'Seven Ages of Man', the 'Four Times of Day' and the 'Four Seasons', he now turned his attention to the 'Four Elements'. Following his now established practice, he first made an intensive investigation through watercolour of the potential of each element, and eventually made two definitive sets of canvases devoted to *Terra*, *Aer*, *Ignis* and *Aqua*. The choice of oval canvas inevitably recalls the 'Four Seasons', but in this case they are turned to the vertical and are more obviously egg-like; the branching, looping, occasionally hooked-back linear networks are built up in a similar method to those in 'A Portable Kingdom' and 'Dilation', but against the oval field a deep structure of continuous, irregular but returning trajectories seems to be implied. As with all his painting since 'Generation', the physical movements the artist makes, the materials and instruments at his disposal, are made the equivalent of the processes of natural creation, and not a symbolic depiction of those processes. This time, though, the painting is stripped down to its most fundamental elements: colour, tonality, gesture, the weight, density and duration of a mark. Everything in the paintings flows from the animation of these base elements.

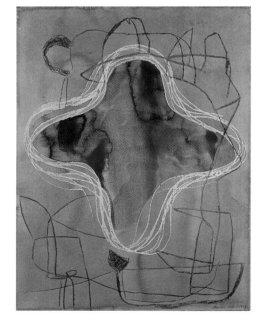

Study for 'Dilation', *Red Track in Grey*
1997, tempera, watercolour and wax
75 x 56 cm
Galerie Clivages, Paris

Spectral Rivers

By 1997 Cockrill had begun to make regular visits to the Conwy estuary in North Wales and established a studio in outbuildings on the estate of Bryn Eisteddfod, overlooking the east shore of the river. This part of Snowdonia was steeped in memories for him, but he was now aware too of the river's particular associations with the history of landscape painting: almost opposite, across the water, was Tyddyn Cynal, the house in which the Victorian painter Henry Clarence Whaite had lived, who himself had close connections with the artists' colony that had formed around David Cox, further up the valley at Betws-y-Coed. Cockrill began to make small paintings directly from the river motif, and in 1998 he exhibited a suite of twenty of these pictures under the title 'Conwy River Cycle' at the Ogilvy and Estill Gallery in Conwy (pp. 110–11). The following year he made a second set, of identical dimensions, which was exhibited in Sydney; both groups have now been largely dispersed.

The Conwy River swells to its widest by Bryn Eisteddfod, but immediately upstream narrows at an elbow where the river current and the incoming tides ceaselessly contend together. The relations of light, weather, tide and current are continually altering in this landscape, but the idea of flux also extends to the artist's own subjective position, bringing something different each time to the painting. The resulting paintings are intensely evocative and atmospheric, and have a dynamic, lyrical quality reminiscent of David Bomberg. Initially Cockrill was circumspect about the works that had been produced in this direct way, and was anxious to maintain a distance between these small landscapes and what he considered to be his more ambitious projects. Nevertheless, the experience of painting so close to the elements did offer a stimulating contrast to the more cerebral paintings he was making in his London studio, and the rediscovery of rivers as a theme was genuinely significant for him. It would soon re-enter the mainstream of his practice.

In 2000 Cockrill was asked to contribute to the exhibition *Afon: River*, which was being organized for the Oriel Mostyn Gallery in Llandudno. The five tall paintings he produced (pp. 112–13) had their origin in the recent, directly observed Conwy landscapes, but they were also an attempt to

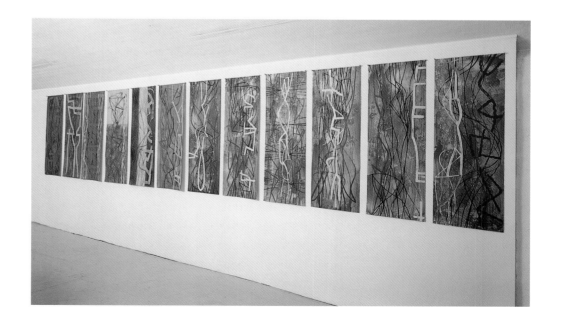

Studio view of studies for **Spectral Rivers**
12 works on paper from a set of 40
Oil and graphite on prepared paper
Each 114 × 42 cm
Courtesy of the artist

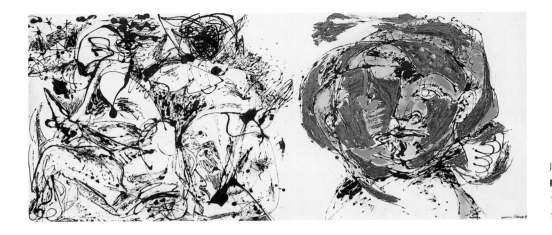

JACKSON POLLOCK
Portrait and a Dream
1953, oil on canvas
146 x 337 cm

explore on a large scale the analogy between the phases of a river and the cycle of human life. The parts are individually titled *Well-head, The Deepening, Night River, Serpentine* and *Confluence*. The metaphor of the life cycle is, of course, inscribed at the very heart of the discourse of physical geography, with rivers represented as having their stages of childhood, youth and maturity; here, the adoption of the upright canvas format inevitably suggests the presence of the figure, and the flow of waters from source to confluence with the sea merges with the idea of human history and experience.

By this time, work on the paintings Cockrill referred to as Divided was already well underway (pp. 102–109). This ambitious series would eventually run to eighty-four paintings on a variety of scales. It provided the basis for an exhibition in Düsseldorf in the early summer of 2000, and other examples were shown concurrently in Paris; there was also the large composition that was exhibited at the Royal Academy, London, in the same year, and which would later be designated as his diploma piece. In contrast to 'Afon Cycle', the paintings are more theoretically driven, dedicated to an investigation of the ideas of contradiction, opposition and difference. In formal terms, they were also the most geometrical and economically handled works Cockrill had created so far.

The series continues the artist's long-standing concern with two-part composition, setting out contrasting forms at either side, one straight-edged and continuing to the limits of the field, the other more organic and self-contained. These could be construed as expressing the principle of difference in a variety of contexts – technology and nature, for example, or male and female. Initially the opposing aspects were closely juxtaposed, rather as they had been in Ash or Place of Fire, but soon the idea of a meaningful interval between them became important. Cockrill references were typically wide: Jackson Pollock's late *Portrait and a Dream*, for example, where the two parts are painted differently and express alternative visions, or, less problematically, Morris Louis's Unfurled paintings, with their expanses of untouched canvas between the intense stains of colour. Cockrill also thought of the use of an extended interval between incidents as the equivalent of passages of silence in music, or the gaps between the stanzas of a poem. In the majority of the paintings, a single, even-coloured ground extends across the whole field, though the angular layering on the left-hand side can be dense enough to threaten to conceal or unbalance it.

The six separate canvases exhibited together under the title *Spectral Rivers* (see frontispiece, pp. 2–3) at the Royal Academy, London, in 2001 were the outcome of another phase of exploratory

drawing (p. 23). The initial impulse came from the example of the sixteenth-century Japanese painter–poet Koetsu; the drawings took the form of long scrolls, worked on the floor, in which the script-like design was laid down in black, white, dark red and grey on a ground splashed with gold powder. In the paintings, bold, angular signs are intertwined with more delicate filaments, creating an effect of subtle amelioration, rather than the stark opposition of systems in the 'Divided' pictures. The enigmatic 'writing' seems to relate at some level to the repeated, downward-flowing river-maps of 'Afon Cycle'. The canvases are ordered according to the colour-sequence of the spectrum (though there is no indigo, in a subtle side-stepping of a purely schematic arrangement), but the 'spectral' of the title has another resonance altogether, suggestive of ghostly waters flowing in some alternative dimension, or a phantom river-system beyond the limits of the physical world.

With the 'Bridge' paintings a number of the themes and formal concerns of Cockrill's recent years can be seen to converge. The first painting to utilize the device of a rudimentary bridge structure was made towards the end of 2001 (p.114), but the distinctive character of the new group was really defined only in the series of canvases painted in the first three months of 2002 (pp. 115–23). The motif of the bridge has an obvious relation to the recent cycles on the theme of rivers, and Cockrill had been preoccupied for some time with water as an element, and the ways in which its character and proper-ties might be depicted. The idea of the bridge, a structure capable of connecting opposite sides, also functions as an obvious symbolic counterpart to the 'Divided' paintings.

Technically, Cockrill follows a procedure established in previous series such as 'A Portable Kingdom' and 'Dilation' by building up the paintings in layers; working through a sequence of pouring, stopping-out, overpainting and disclosure, the relationship between the successive stages is revealed with absolute distinctness in the paintings' final form. The initial stage of the process presents the closest analogy to the action of water itself, as rivulets of thinned-out paint are sluiced down the canvas. The main linear part of the design is traced out while the canvas is in a horizontal position, a looping, serpentine configuration laid down by the broad track of the brush in a medium that also acts as a resist; this layer is rendered visible only in the penultimate stage of the process when a field of colour is laid over it. The strongly coloured architectural aspect is added at the last, framing the amor-phous elements and binding them together.

The richly textured forms of the waters seem to braid, gather and flare out, taking on the quality of swirling, sumptuous draperies rather than that of a liquid element; there is an unmistakable note of opulence in these paintings that is not so familiar in Cockrill's work, though it might be anticipated in the fiery baroque of *The Golden Boy of Pye Corner*, and is there indirectly in the *Magnus* paintings of the 'Dilation' series, with their allusion to the ornamental slashings in the garments of an Old Master painting. The colouring of the bridge forms is of a different order, and sometimes seems as bold as a neon strip, a filament of pure colour cutting across the pictorial field. The bridges themselves take the archetypal form of a simple post-and-lintel structure; the emphatic verticals and horizontals inevitably recall Mondrian, and the effect of each painting is subtly dependent on the decision to extend a line right to the edge or to attenuate it within the picture space, just as it is in Mondrian's own practice. The rectilinear structures reiterate the fundamental shape of the paintings' support, so that they can appear momentarily like pictures within a picture, or paintings stacked one behind the other. In the context of a series still perhaps only in its opening stages, the effect is curiously suggestive, as if some of the paintings to come are already adumbrated – new lines of possibility opening up.

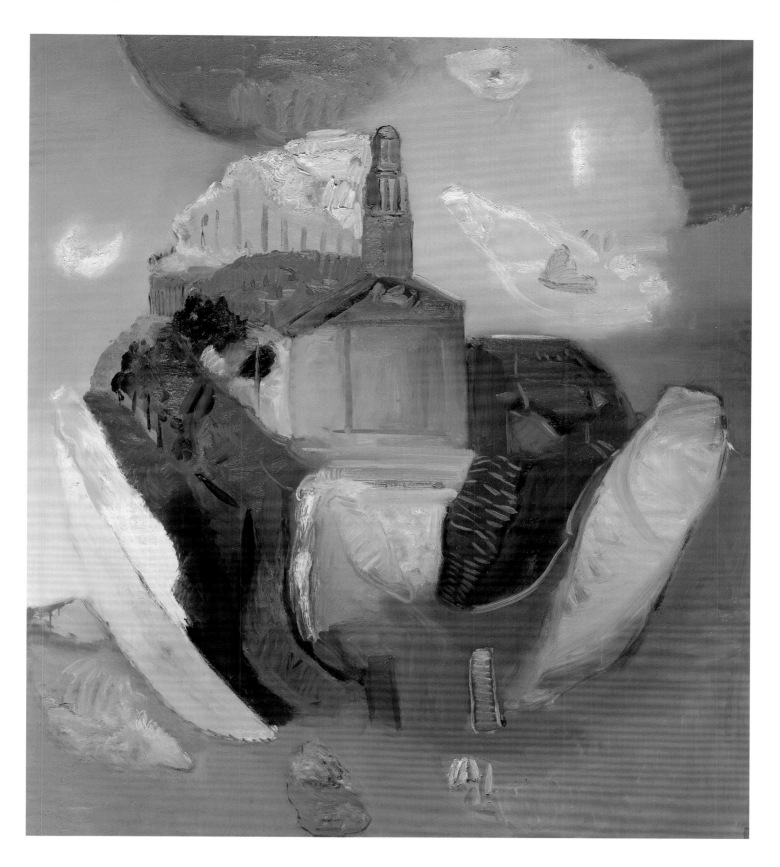

Corona Lucis, 1988–89, oil on canvas, 203 × 178 cm, Bernard Jacobson Gallery, London

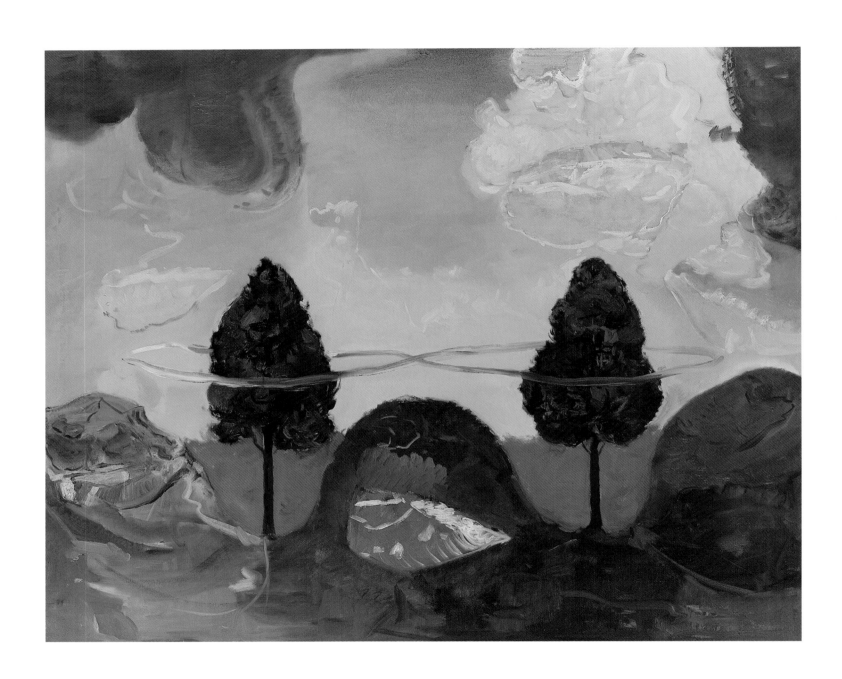

Ariadne's Thread, 1989, oil on canvas, 187.2 × 230 cm, courtesy of the artist

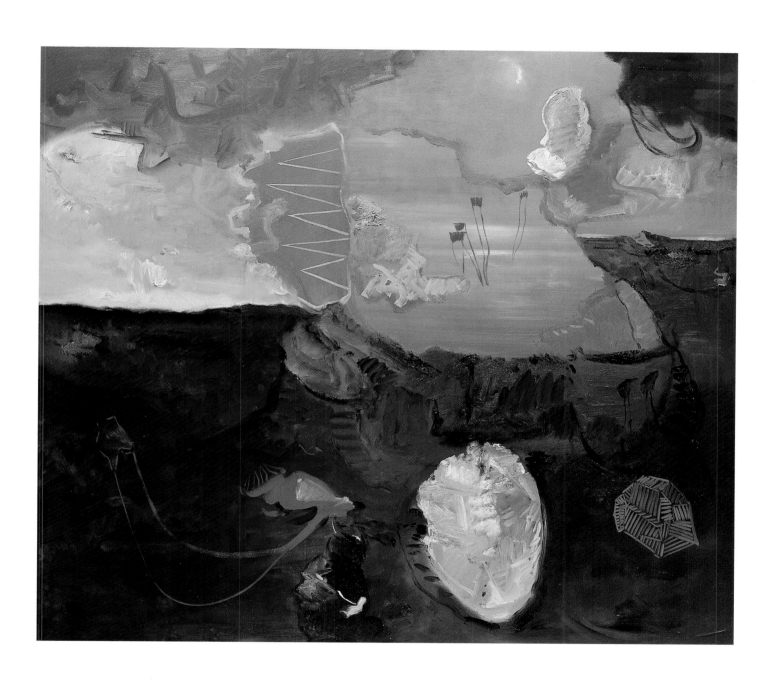

Song of the Earth, 1989, oil on canvas, 177.5 × 203 cm, Bernard Jacobson Gallery, London

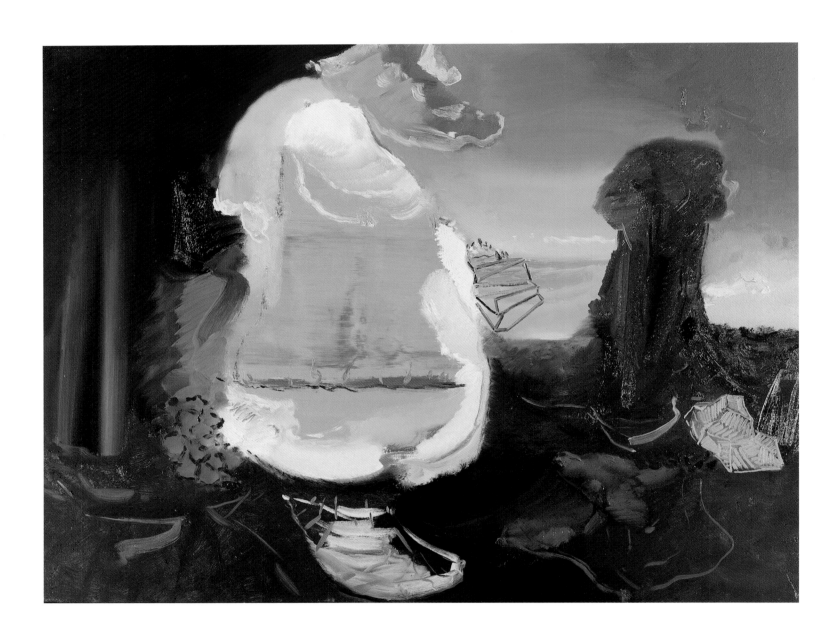

Liberty, 1989, oil on canvas, 106.5 × 139.5 cm, collection of Mr and Mrs Richard Wright

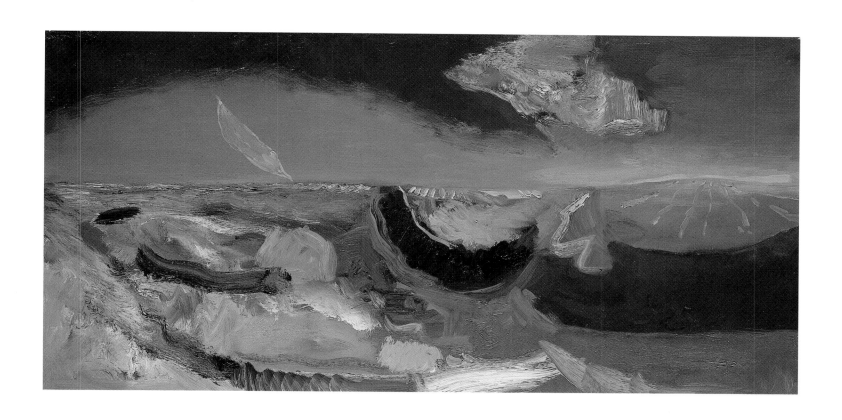

Deluge, 1989, oil on linen, 50.2 × 99.7 cm, private collection

Clearing, 1989, oil on linen, 50 × 100 cm, private collection

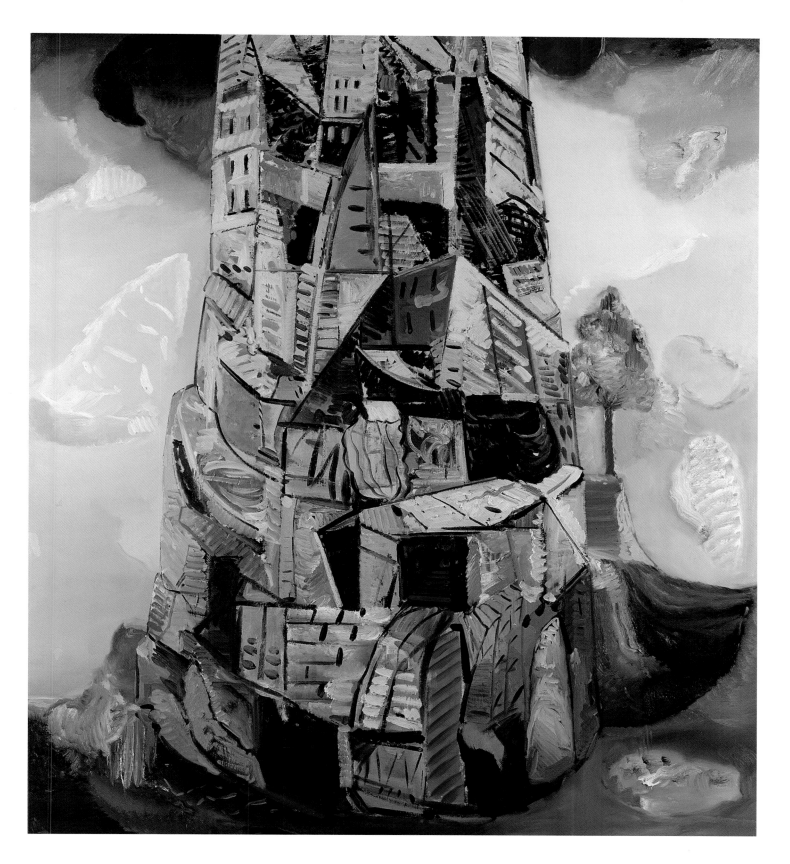

***The Castle**, 1989, oil on canvas, 203.2 × 177.8 cm, courtesy of the artist*

33

Delta, 1989, oil on canvas, 71 × 91.5 cm, private collection

Sentinel, 1990, oil on canvas, 178 × 203 cm, collection of DZ Bank, London

36 ***Broken Hill***, 1989, oil on canvas, 150 × 300 cm, collection of Pauline and Ray Treen, London

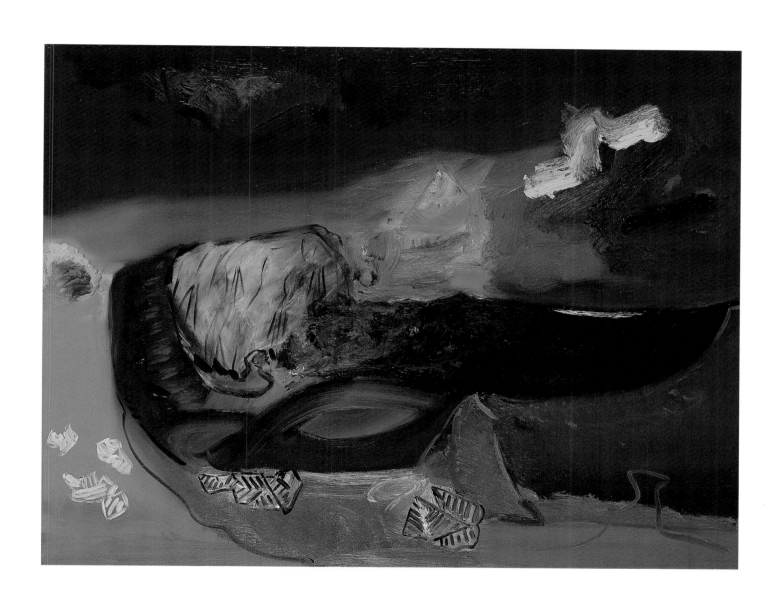

Moonrise with Rocks, 1990, oil on linen, 71 × 91.4 cm, collection of Patrick Frochen, Paris

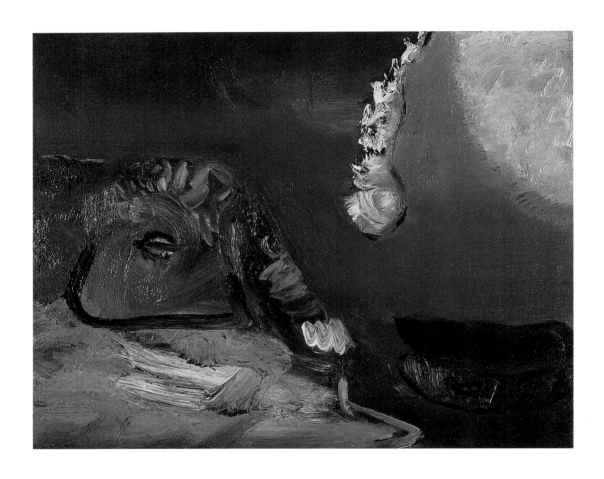

Falling Cloud, 1990, oil on linen, 40 × 51 cm, collection of Daniel Oppenheim

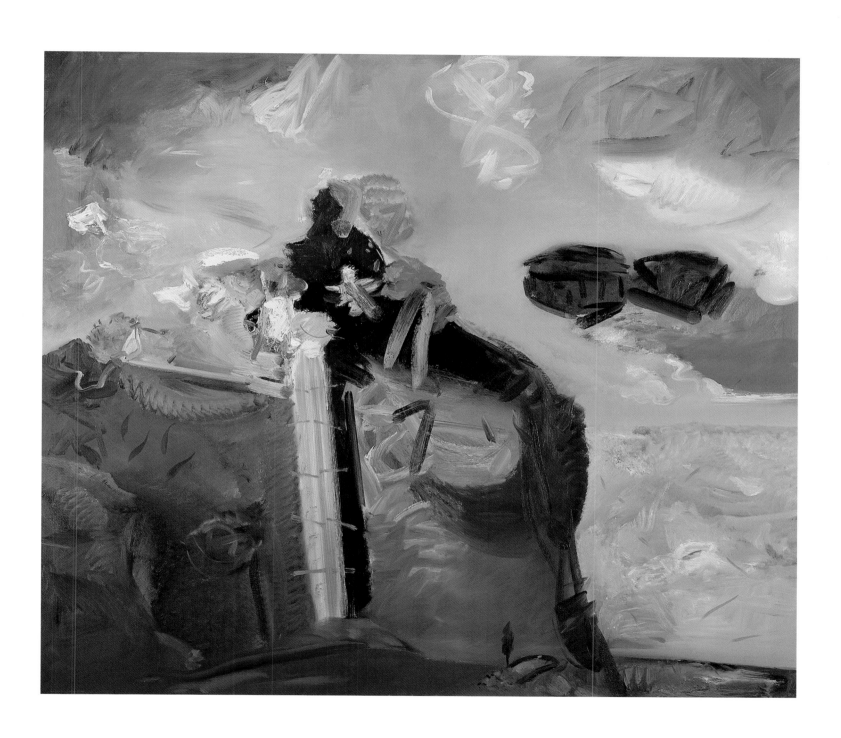

Partition, 1991, oil on linen, 178 × 203.5 cm, private collection

39

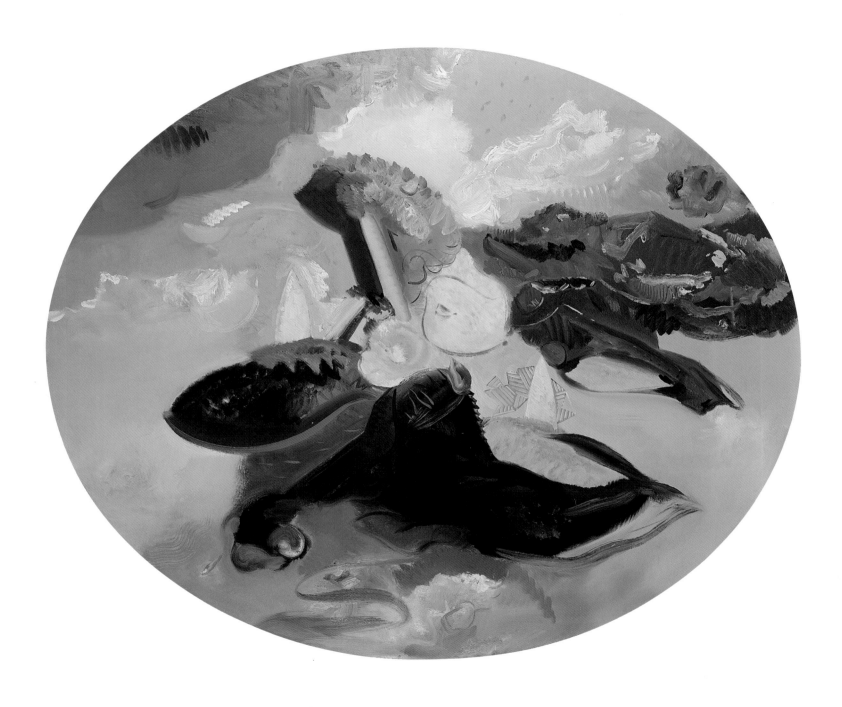

Spring, 1990, oil on canvas, 173 × 206.5 cm, Walker Art Gallery, Liverpool

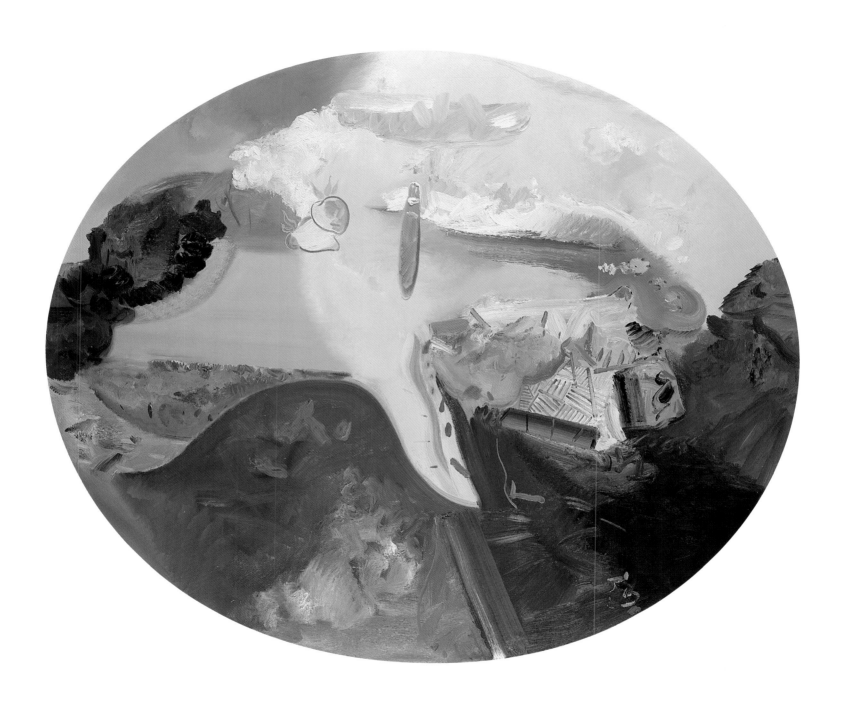

Summer, 1990, oil on canvas, 173 × 206.5 cm, Walker Art Gallery, Liverpool

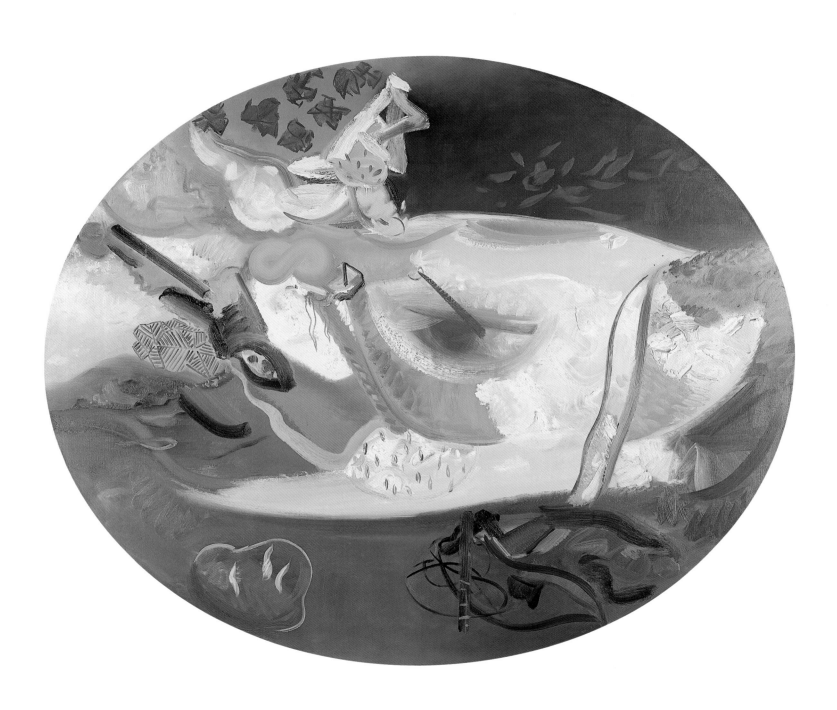

Autumn, 1990, oil on canvas, 173 × 206.5 cm, Walker Art Gallery, Liverpool

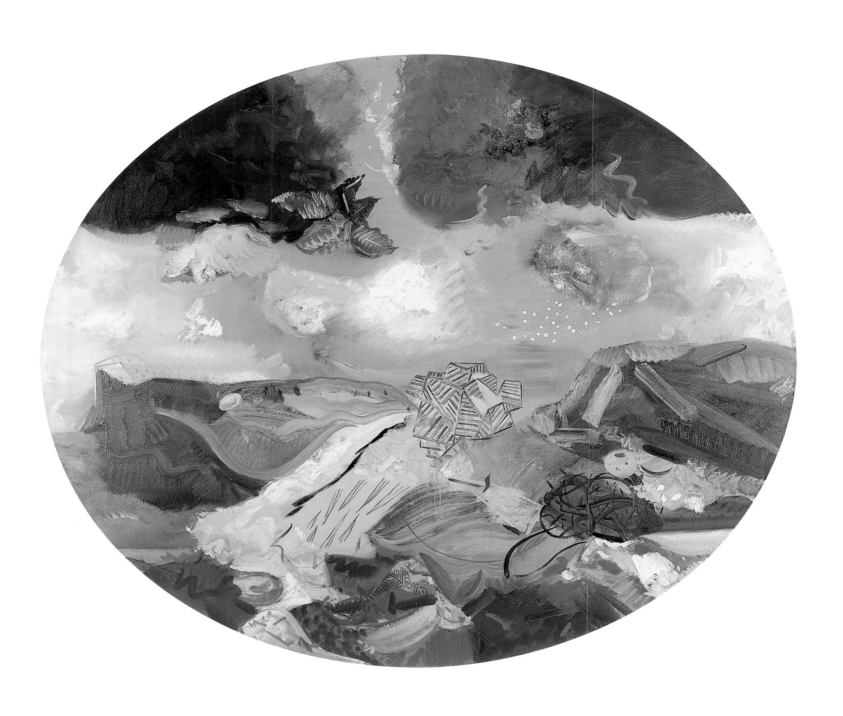

Winter, 1990, oil on canvas, 173 × 206.5 cm, Walker Art Gallery, Liverpool

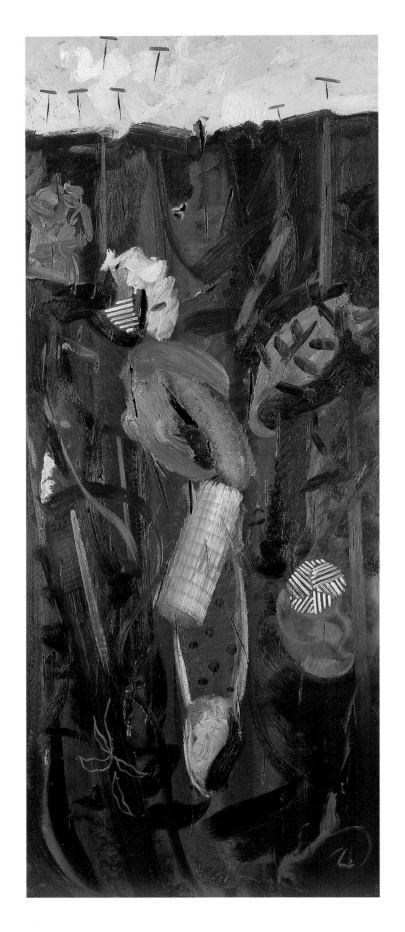

Last Field, 1991, oil on wood panel, 203.2 × 81.2 cm,
Bernard Jacobson Gallery, London

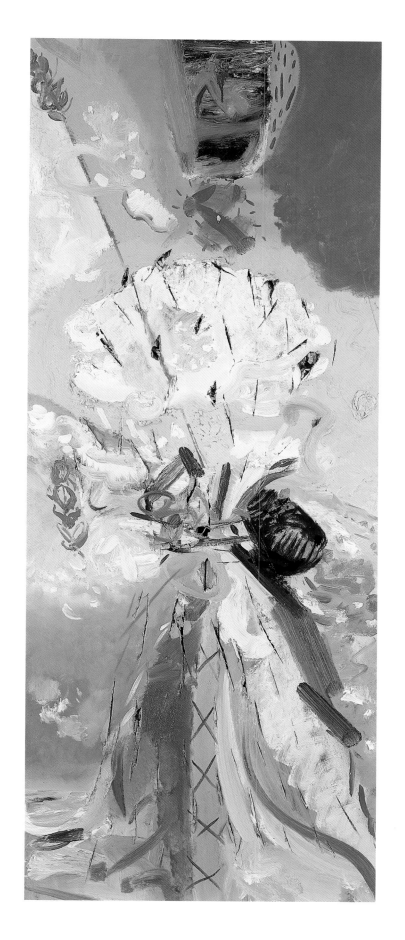

Sheaf, 1991, oil on wood panel, 203.2 × 81.2 cm,
Susan Kasen Summer and Robert D. Summer collection, New York

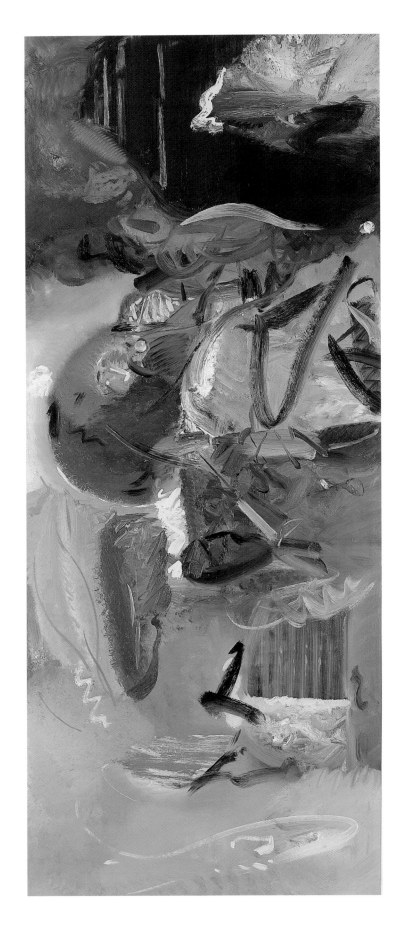

The River, 1991, oil on wood panel, 203.2 × 81.2 cm,
Bernard Jacobson Gallery, London

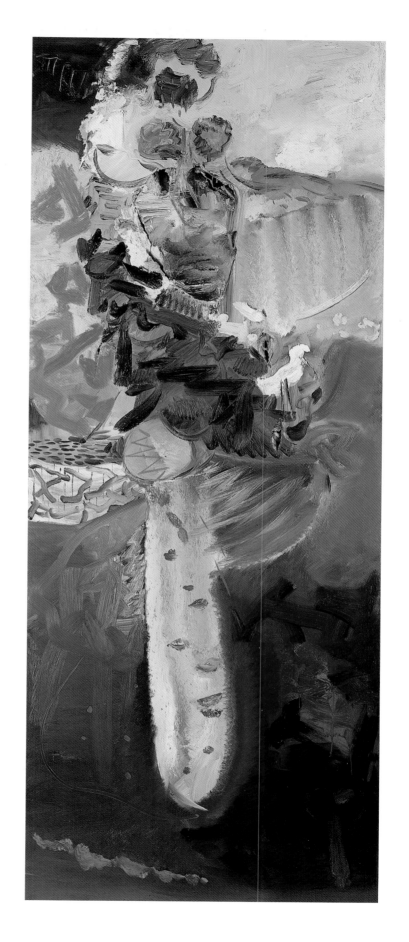

Cove, 1991, oil on wood panel, 203.2 × 81.2 cm,
Bernard Jacobson Gallery, London

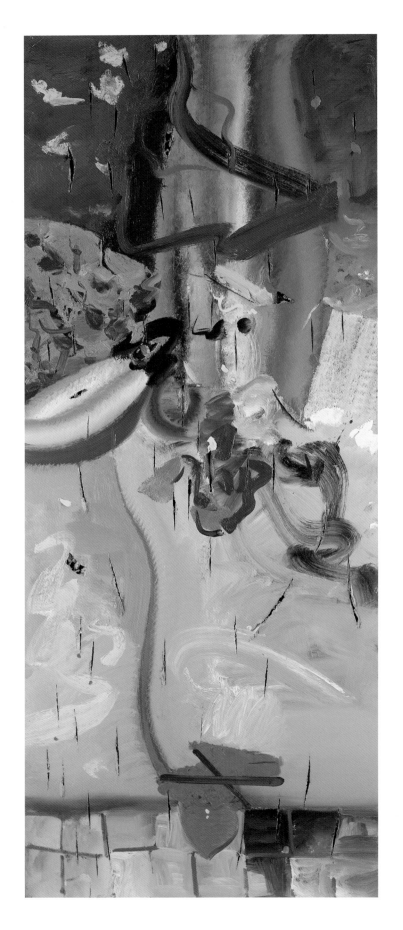

48

Red Rain, 1991, oil on wood panel, 203.2 × 81.2 cm,
Bernard Jacobson Gallery, London

Hanging Tree, 1991, oil on wood panel, 203.2 × 81.2 cm,
Bernard Jacobson Gallery, London

Night, 1991, oil on wood panel, 203.2 × 81.2 cm,
Bernard Jacobson Gallery, London

*Wheat: **Three Paths #1***, 1992, oil on canvas, 200 × 175 cm, Bernard Jacobson Gallery, London

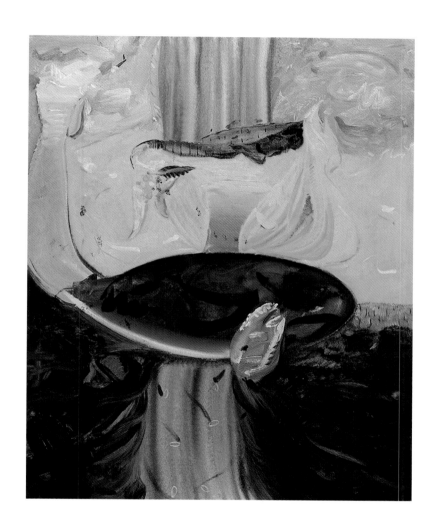

Wheat: Three Paths #3, 1992, oil on canvas, 200 × 175 cm, Bernard Jacobson Gallery, London 53

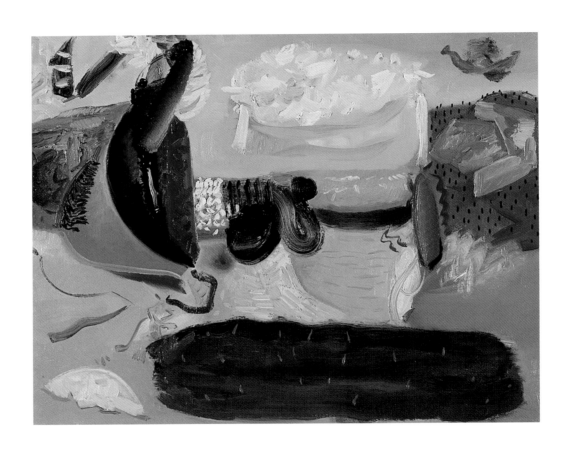

Wheat: New Growth, 1992, oil on linen, 80 × 100 cm, Anthony Hepworth

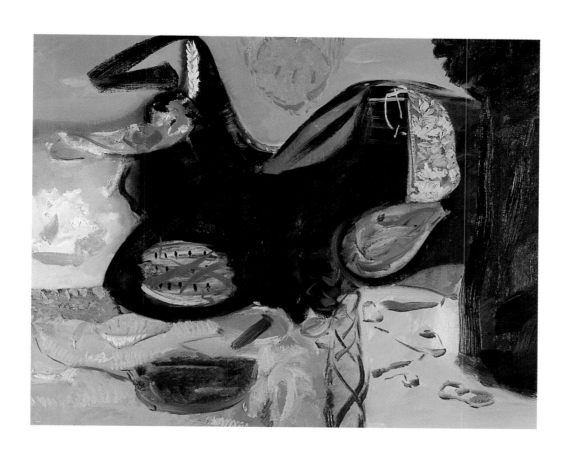

Wheat: In The Lane, 1992, oil on linen, 80 × 100 cm, Annandale Galleries, Sydney, NSW

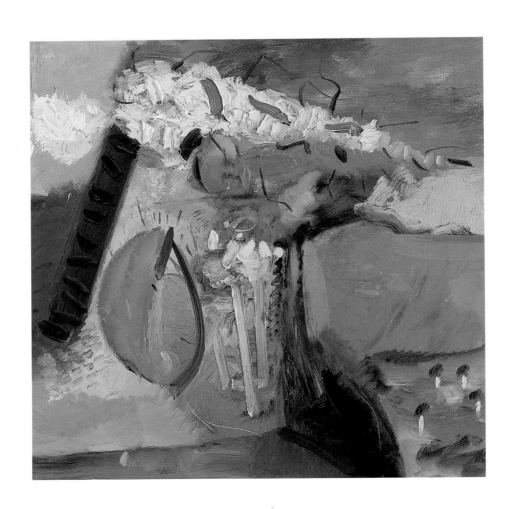

Wheat #8, 1992, oil on linen, 56 × 56 cm, collection of Cindy and Rick Wells

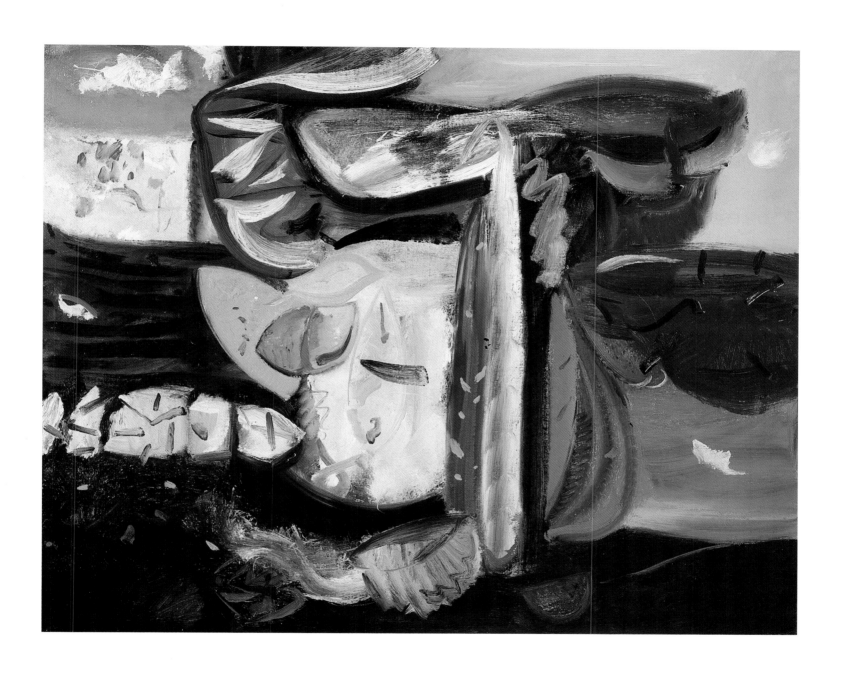

Wheat: Insemination, 1992, oil on linen, 80 × 100 cm, private collection

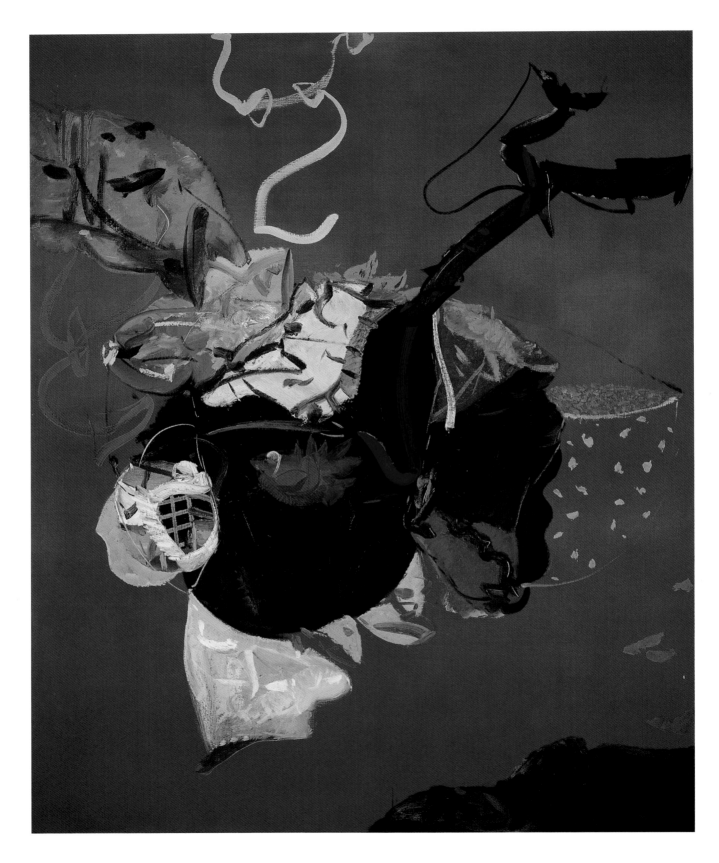

Beyond, 1993, oil on linen, 250 × 200 cm, Bernard Jacobson Gallery, London

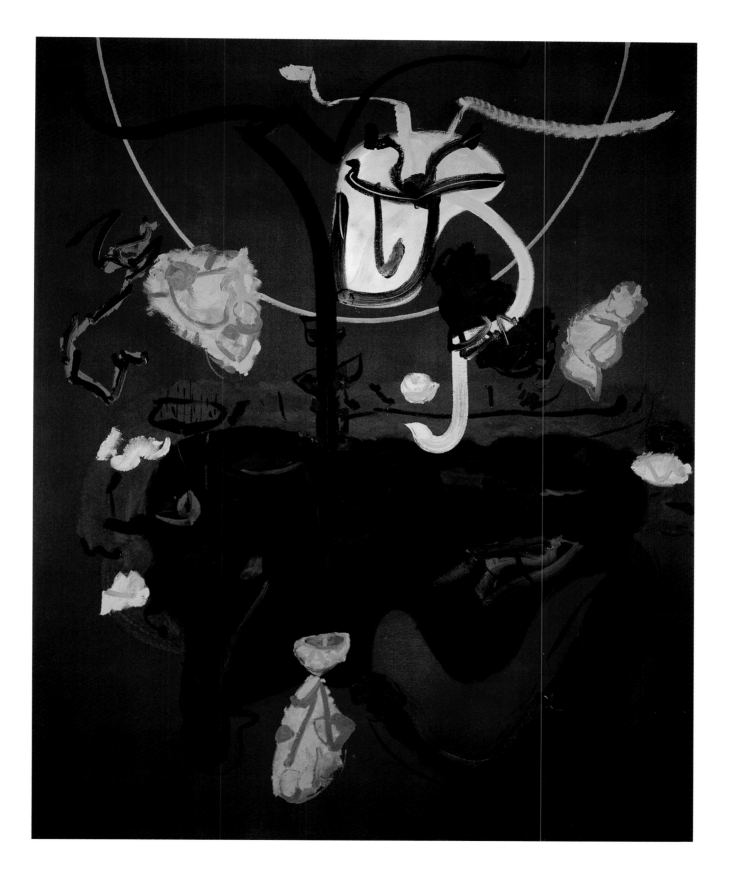

October Moon, 1993, oil on linen, 250 × 200 cm, Bernard Jacobson Gallery, London

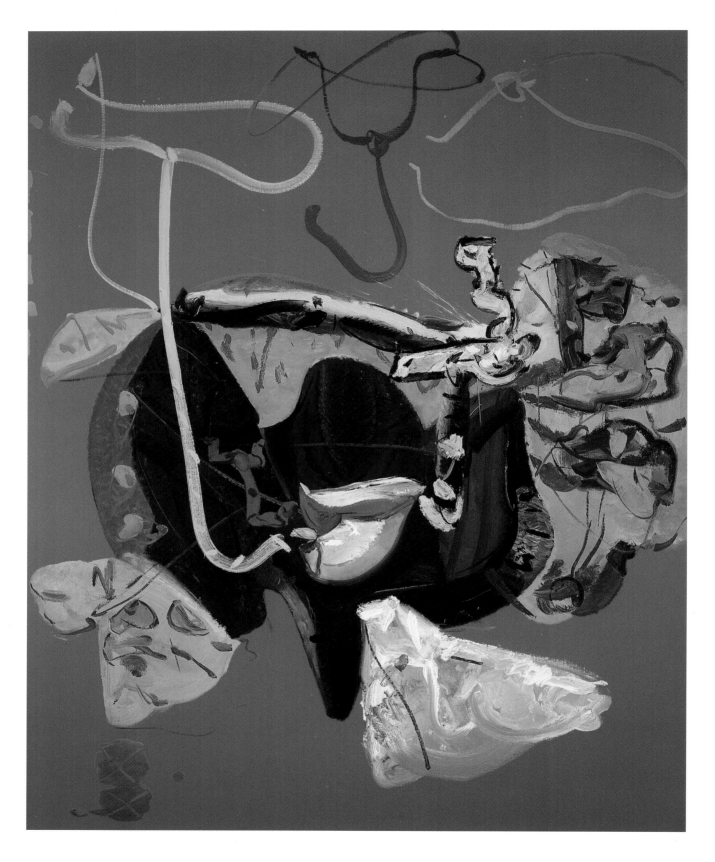

Anamnesis, 1993, oil on linen, 250 × 200 cm, Bernard Jacobson Gallery, London

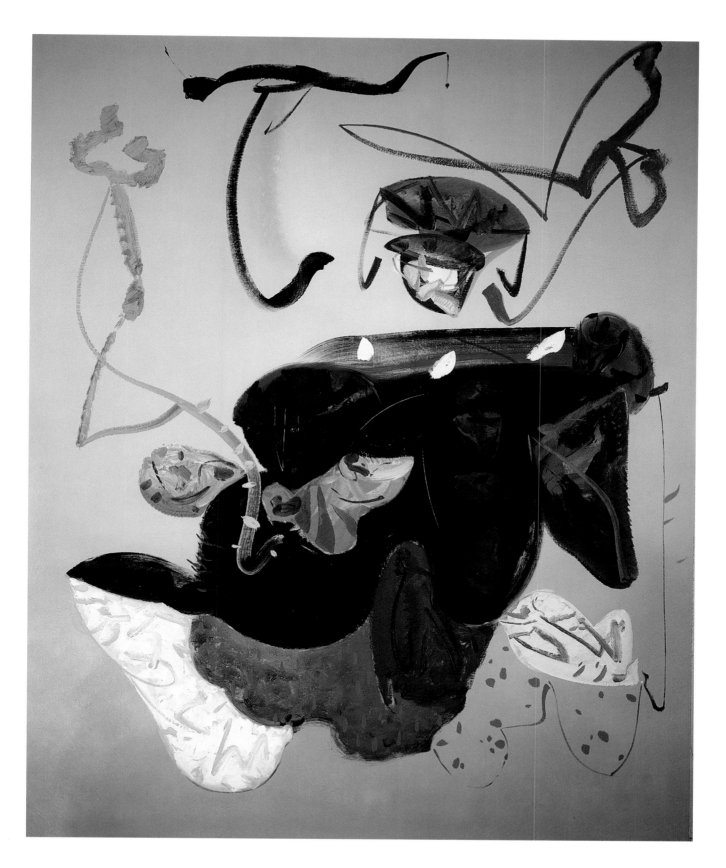

Ash, 1993, oil on linen, 250 × 200 cm, Bernard Jacobson Gallery, London

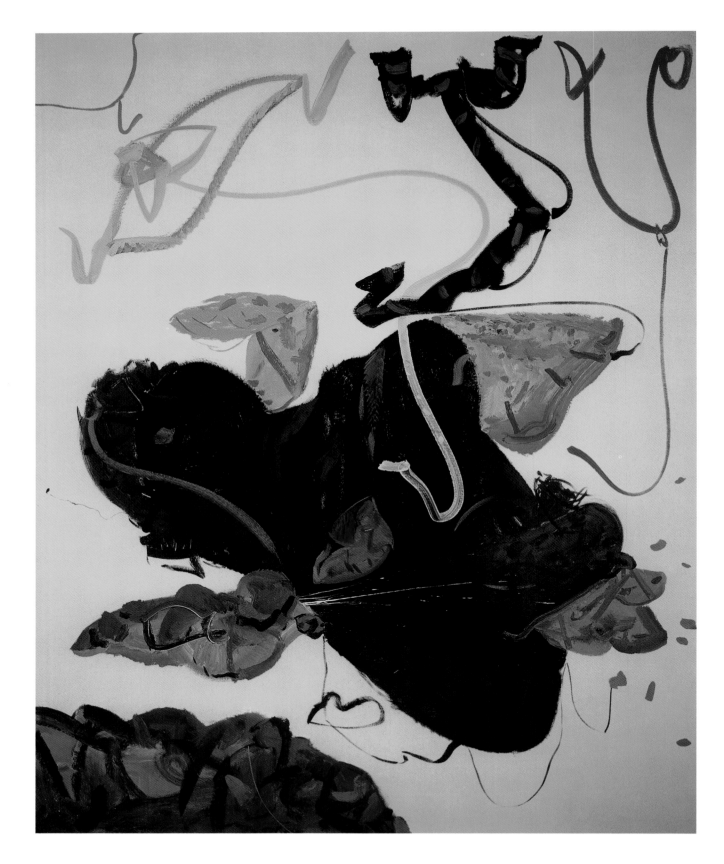

Porphyry, 1993, oil on linen, 250 × 200 cm, private collection

Generation – Clay, 1993, oil on linen, 50 × 45 cm, Bernard Jacobson Gallery, London

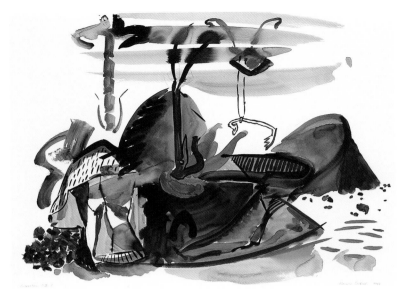

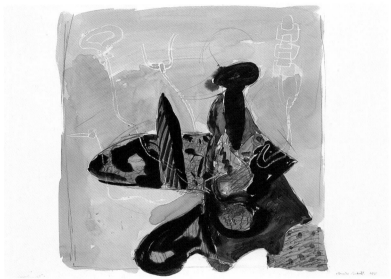

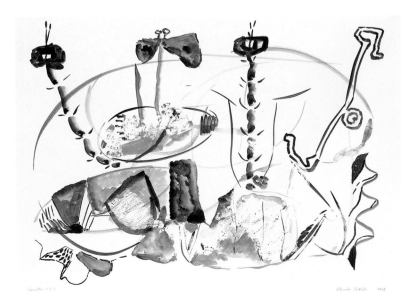

Generation #1, ***#2*** and ***#3*** of 35, 1993, watercolour, pencil, wax, 56 × 76 cm, private collection, Paris

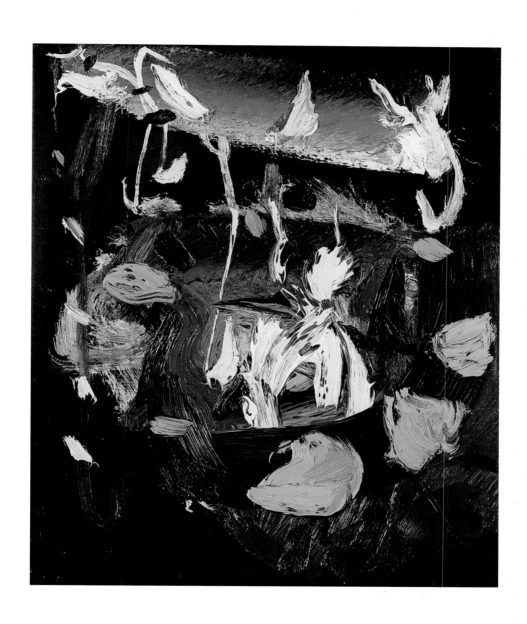

Out of Black, 1993, oil on linen, 61 × 51 cm, Bernard Jacobson Gallery, London

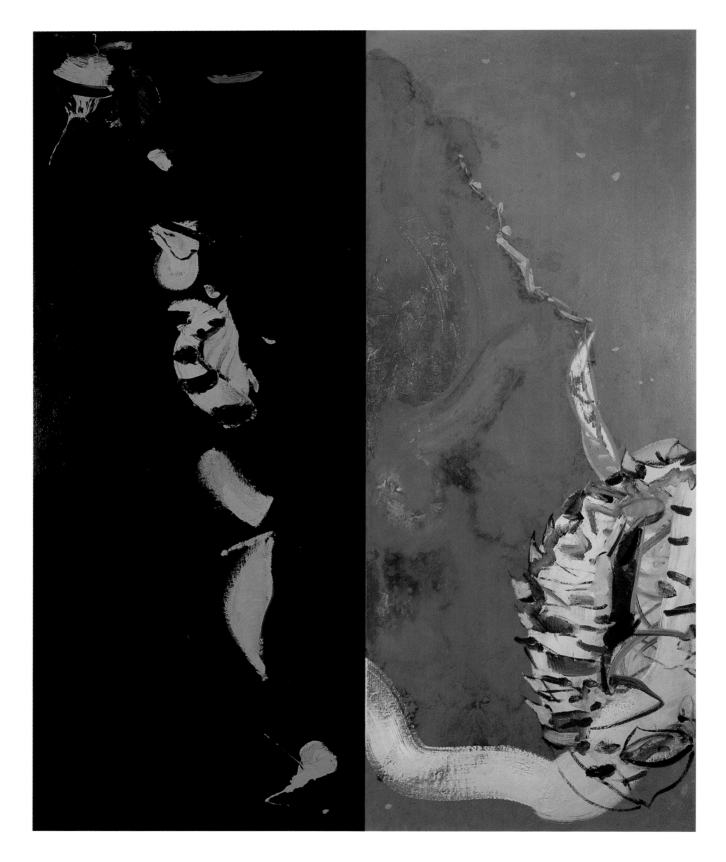

The Golden Boy at Pye Corner, 1994, oil on canvas on wood panel, 203.5 × 164 cm, collection of Cindy and Rick Wells

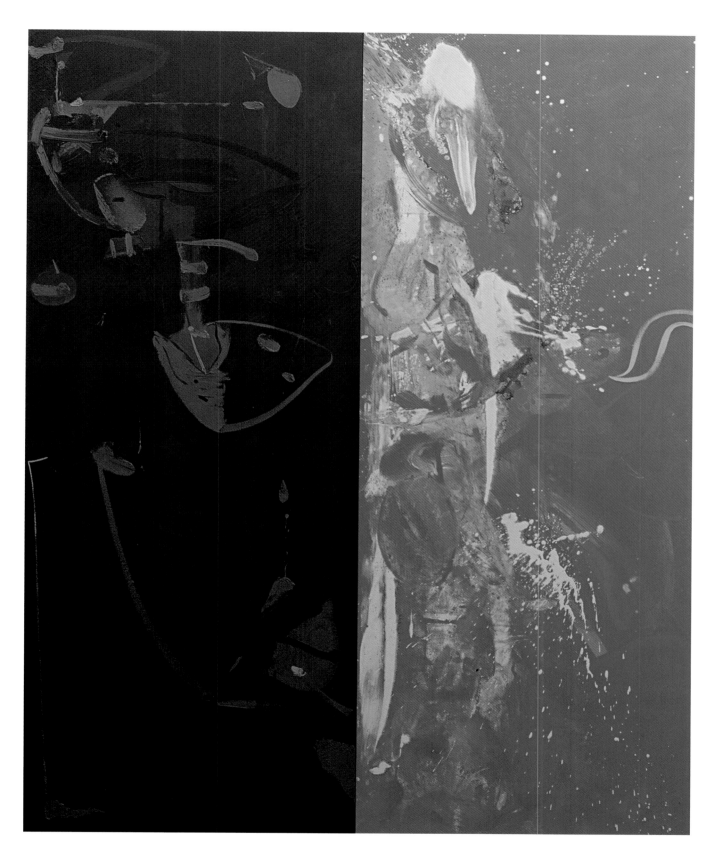

Place of Fire – Cry, 1994, oil on canvas on wood panel, 203.5 × 164 cm, collection of Nigel Slydell

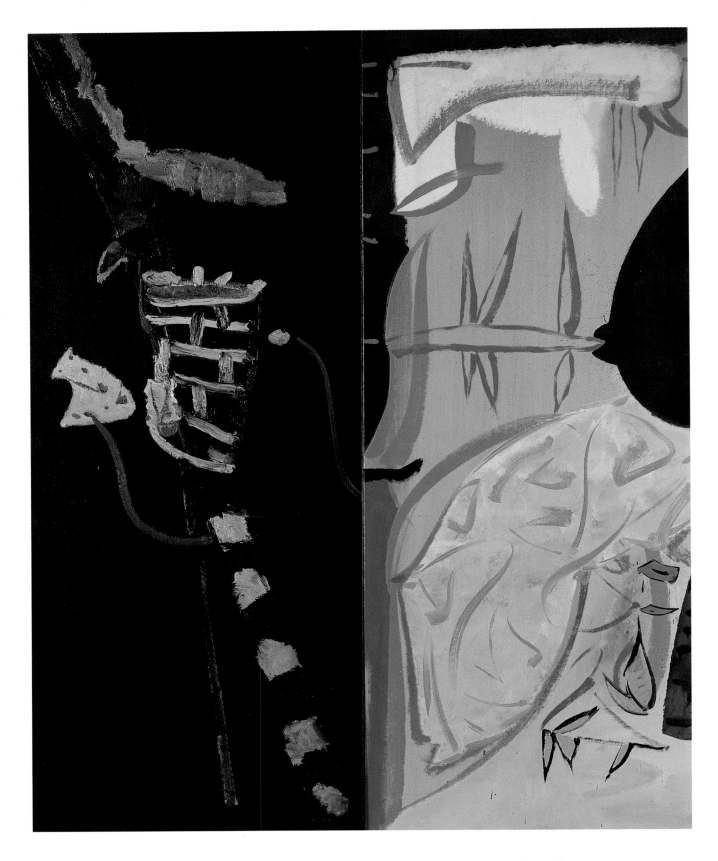

Place of Fire – Aspirant, 1994, oil on canvas on wood panel, 203.5 × 164 cm, Bernard Jacobson Gallery, London

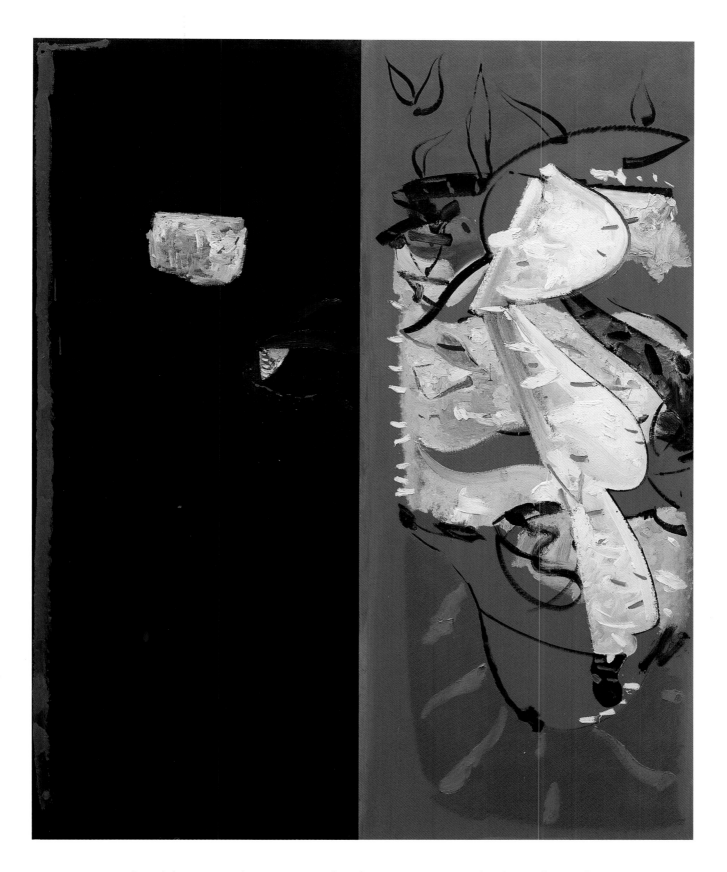

Place of Fire #2, 1994, oil on canvas on wood panel, 203.5 × 164 cm, Bernard Jacobson Gallery, London

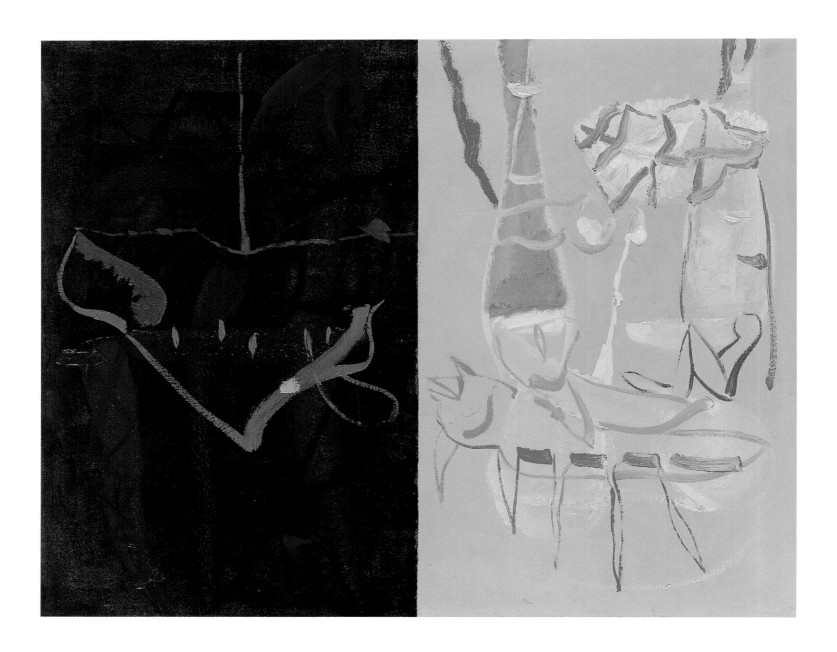

Ash #5, 1995, oil on linen, 80 × 100 cm, Bernard Jacobson Gallery, London

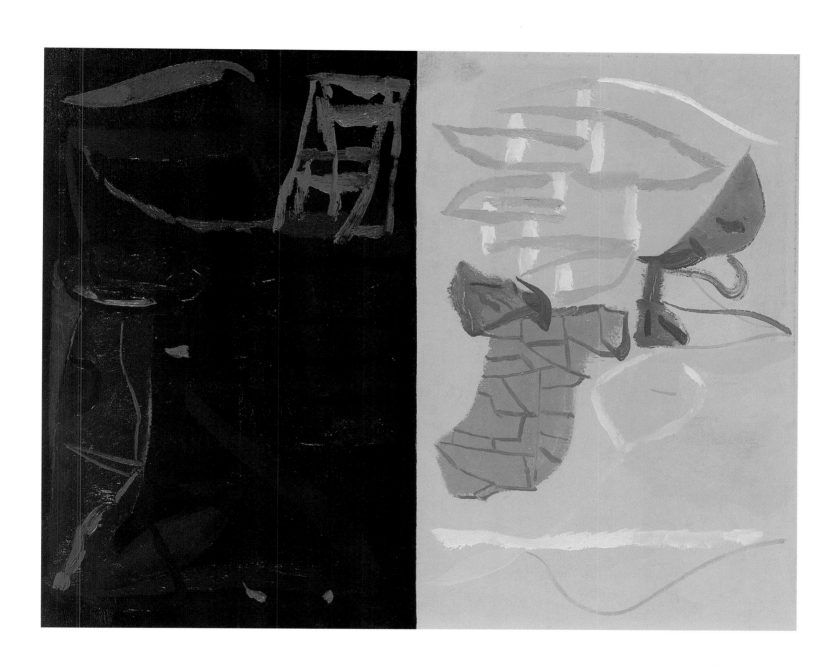

Ash #7, 1995, oil on linen, 80 × 100 cm, Bernard Jacobson Gallery, London

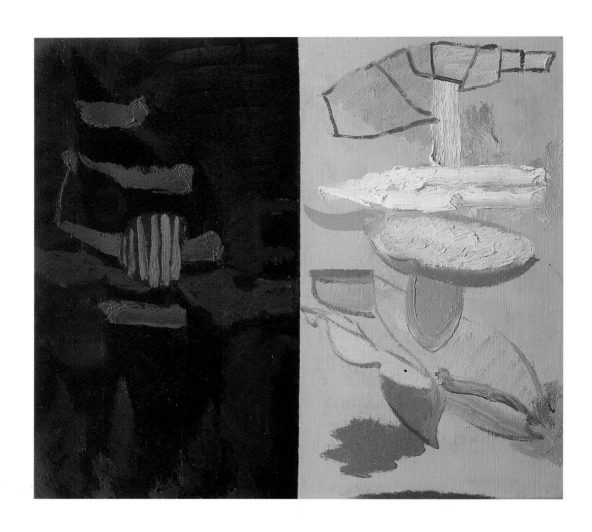

Ash #10, 1995, oil on linen, 45 × 50 cm, collection of William Sibree, Paris

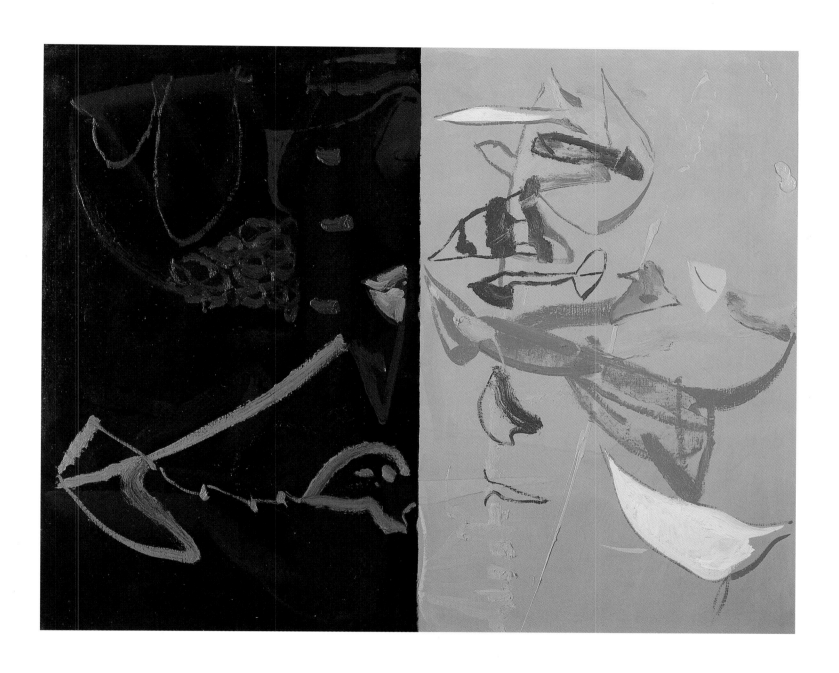

Ash #15, 1995, oil on linen, 80 × 100 cm, collection of S. Deniniolle, Paris

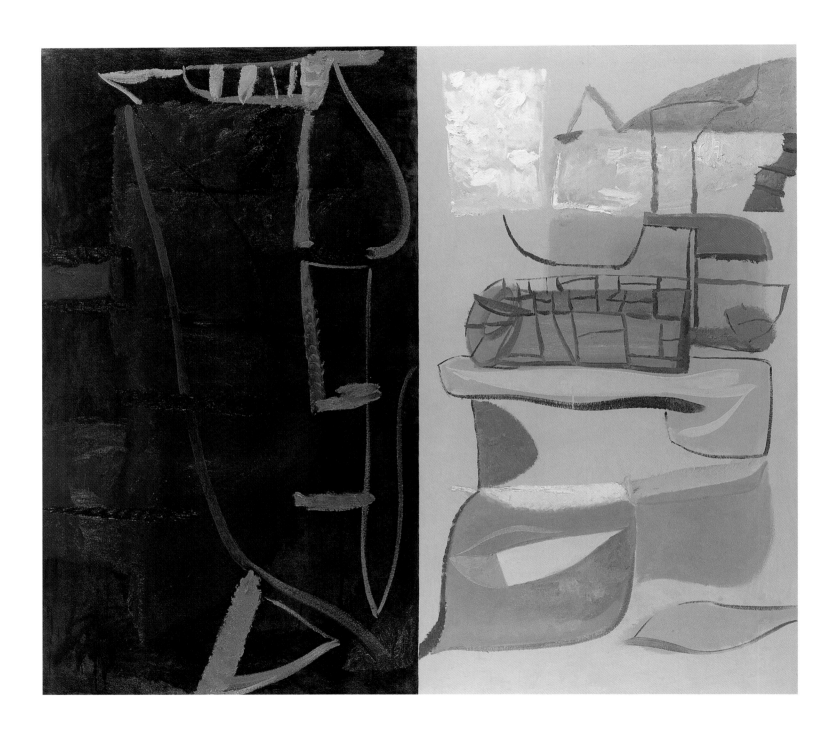

Ash – Rose Fracture, 1995, oil on linen, 200 × 225 cm, Bernard Jacobson Gallery, London

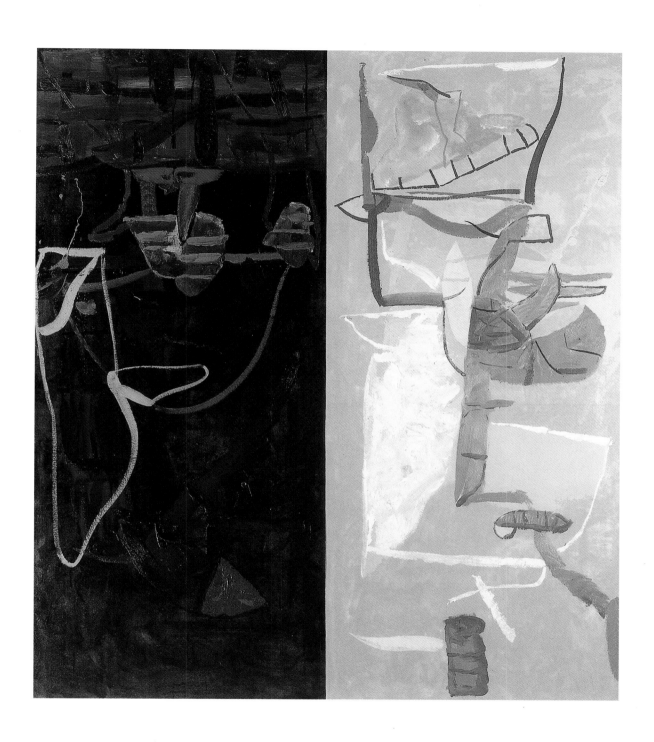

Ash – Phoenix, 1995, oil on linen, 225 × 200 cm, Bernard Jacobson Gallery, London

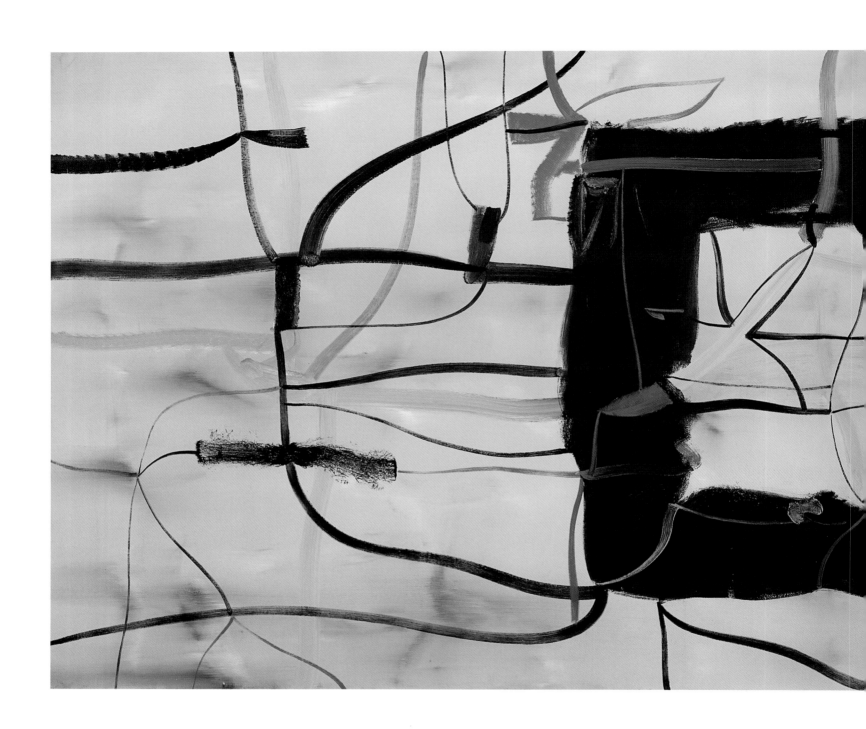

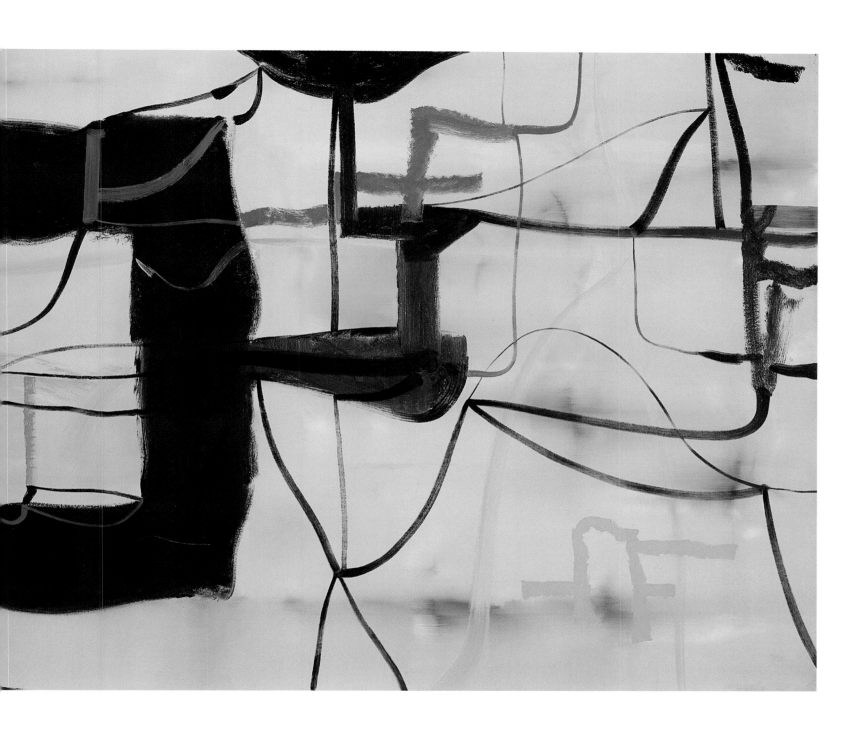

Land of Nod, 1996, oil on canvas, 173 × 412 cm, Bernard Jacobson Gallery, London

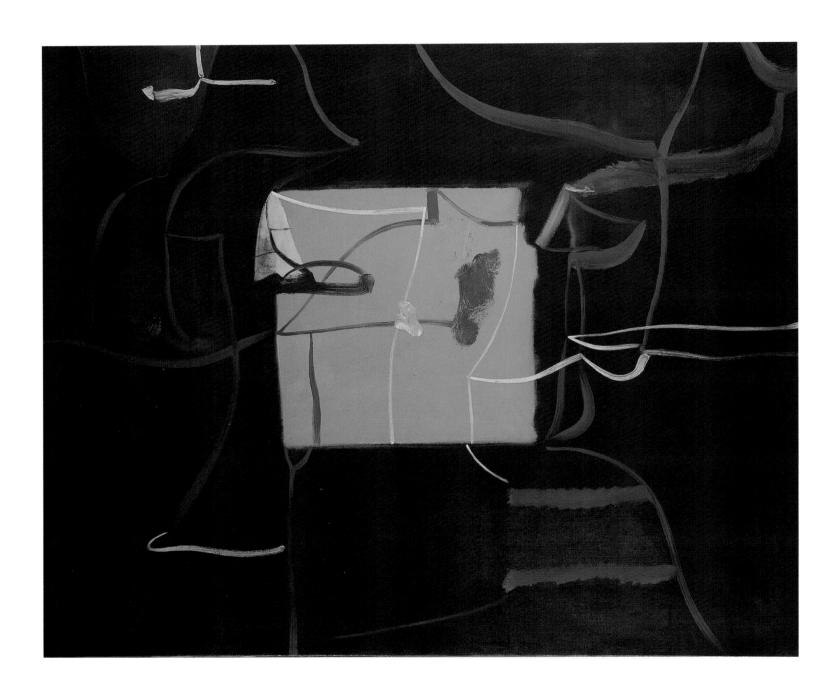

Next Last Walk, 1996, oil on linen, 137 × 163 cm, Bernard Jacobson Gallery, London

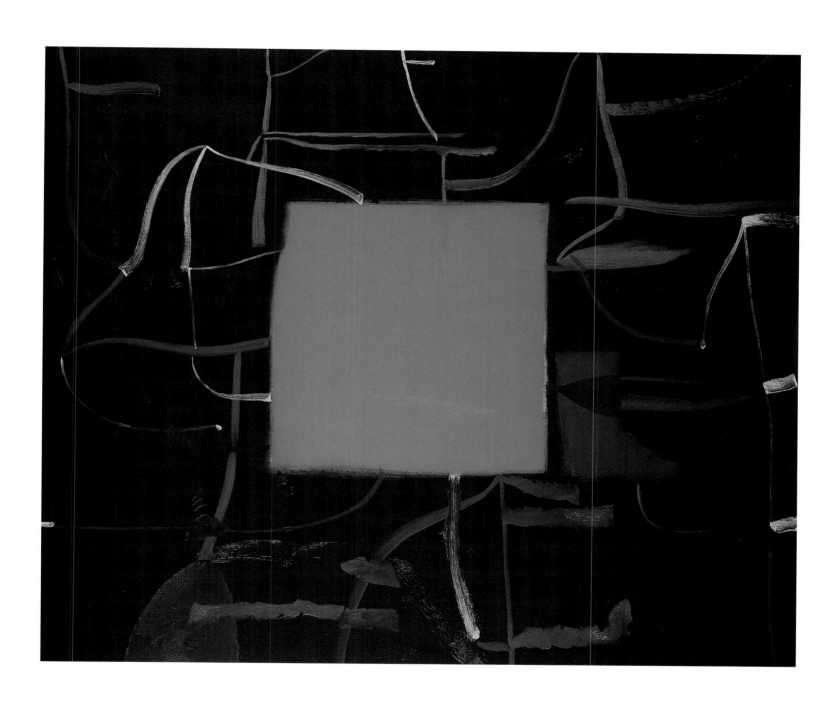

Interior, 1996, oil on linen, 137 × 163 cm, Bernard Jacobson Gallery, London

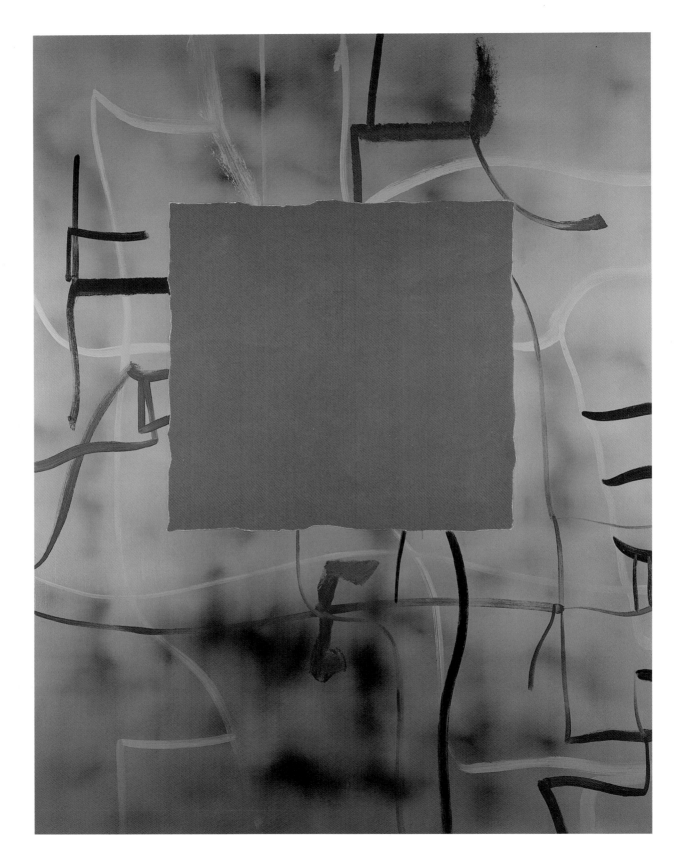

Heart, 1996, oil on canvas, 275 × 203 cm, Bernard Jacobson Gallery, London

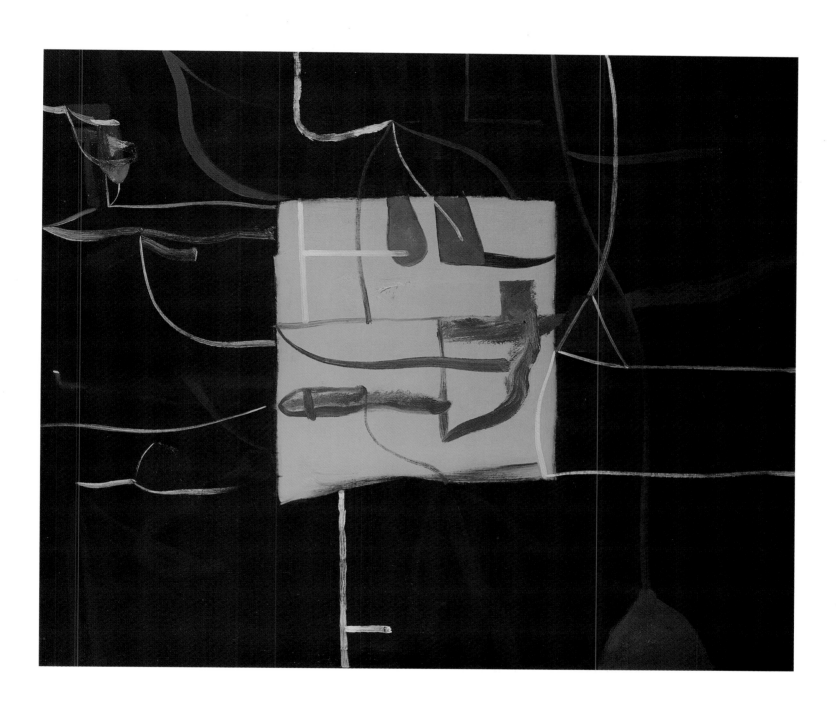

Grisette, 1996, oil on linen, 137 × 163 cm, collection of Karen and Peter Wright

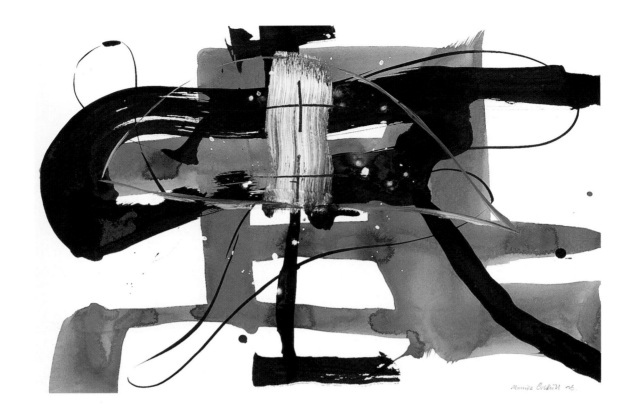

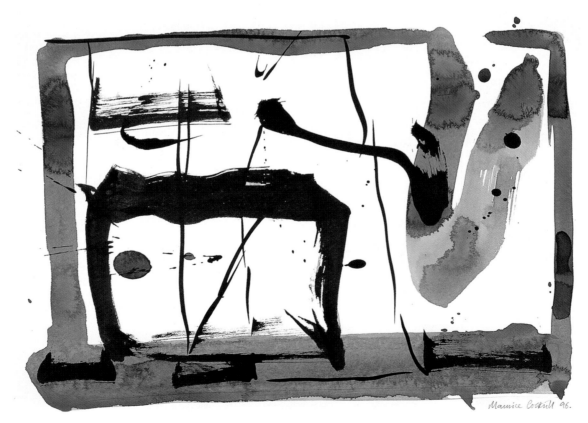

Studies for 'A Portable Kingdom', 1996, gouache on paper, 32 x 42 cm, courtesy of the artist

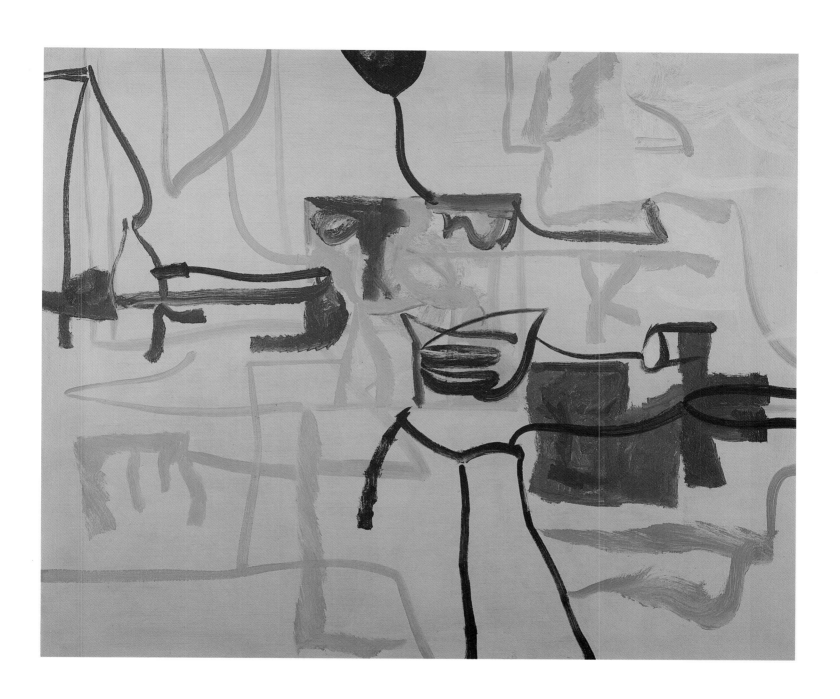

Cinnabar Walking, 1996, oil on linen, 137 × 163 cm, collection of Nina Grunfeld

Scarlet Progress, 1996, oil on flax, 173 × 412 cm, Bernard Jacobson Gallery, London

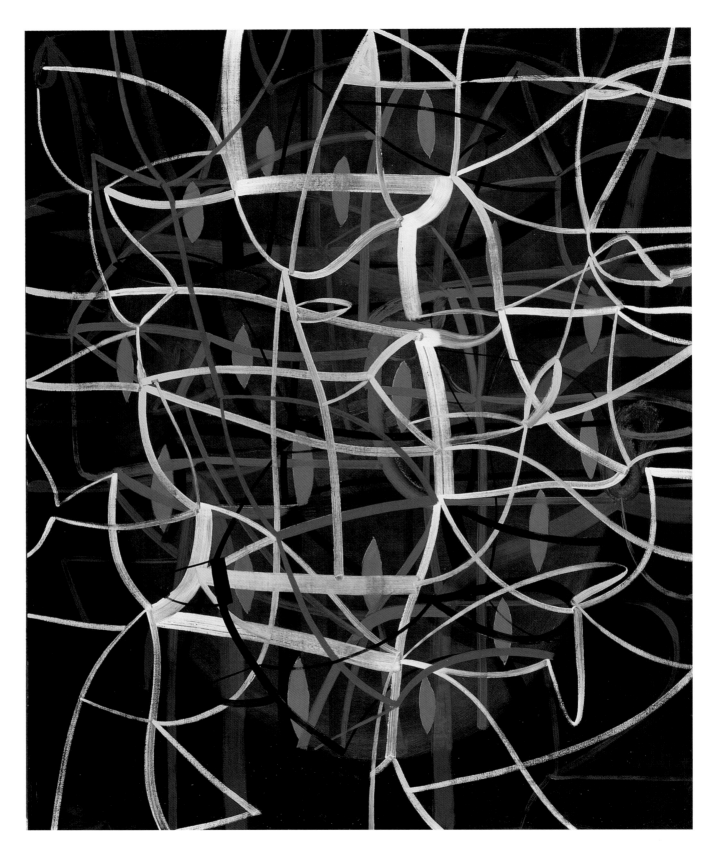

Magnus 4: Red Rain, 1997, oil on canvas, 300 × 244 cm, Galerie Bugdahn und Kaimer, Düsseldorf

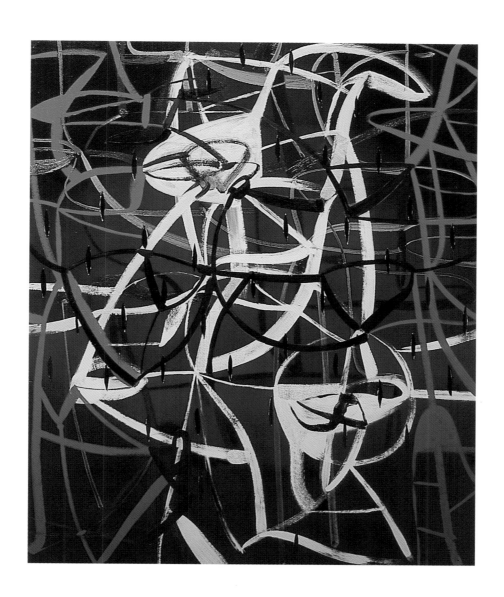

Rent, 1997, oil on canvas, 183 × 152.5 cm, private collection, Paris

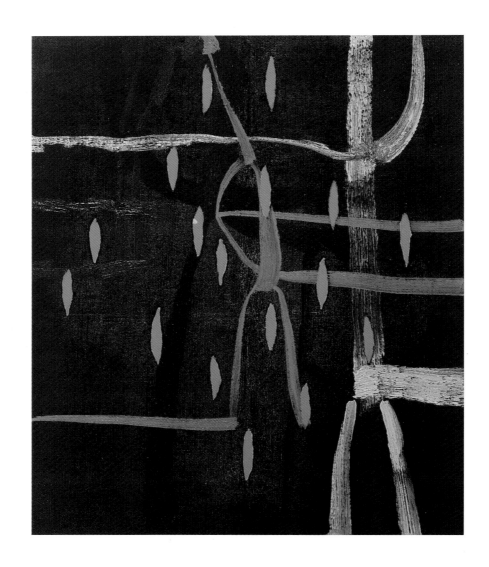

Magnus 1, 1997, oil on linen, 60 × 50 cm, collection of DZ Bank, London

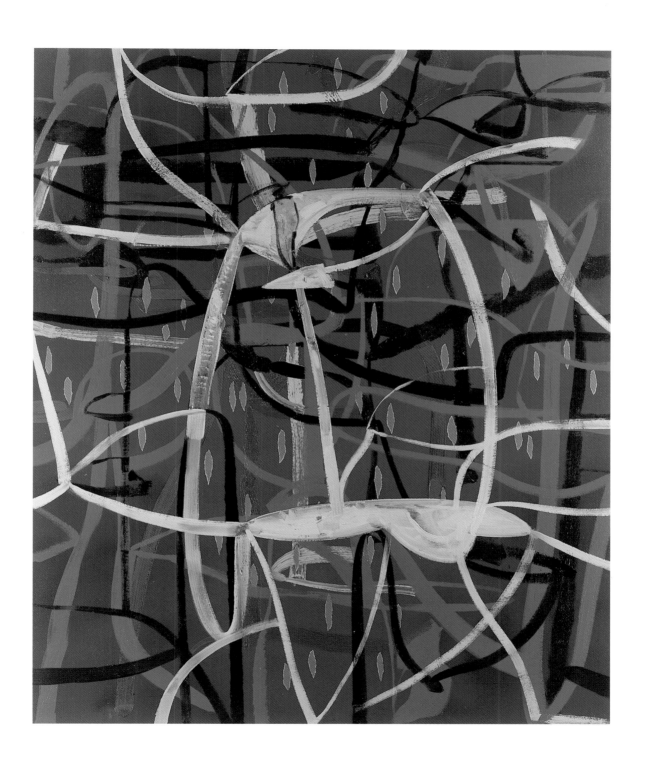

Black Lane, 1997–98, oil on canvas, 183 × 152.5 cm, Galerie Bugdahn und Kaimer, Düsseldorf 89

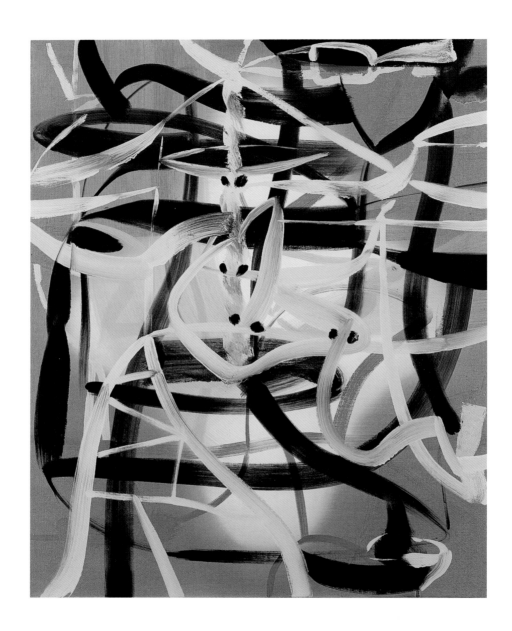

Violet Dilation, 1997–98, oil on linen, 100 × 80 cm, private collection

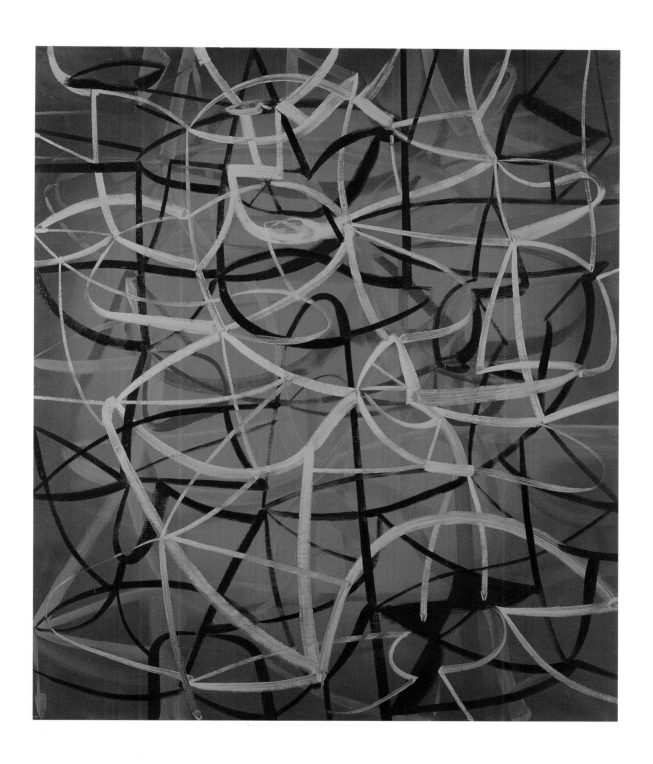

Red Labyrinth, 1998, oil on linen, 163 × 137 cm, collection of DZ Bank, London

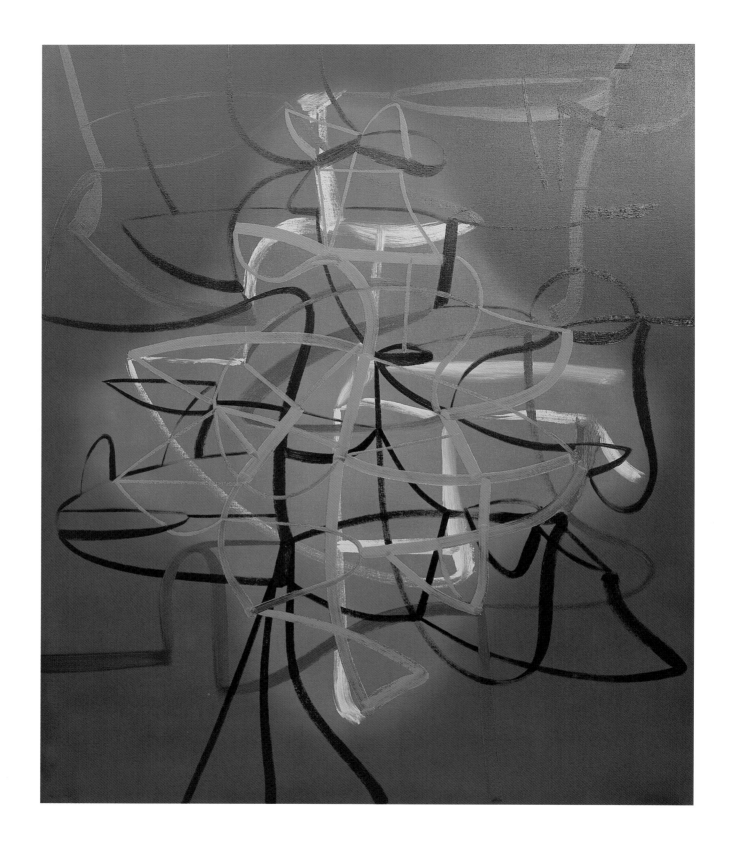

Broken Way, 1997, oil on canvas, 182 × 152.5 cm, collection of Pauline and Ray Treen, London

Moonrise, 1998, oil on canvas, 152.5 × 188 cm, courtesy of the artist

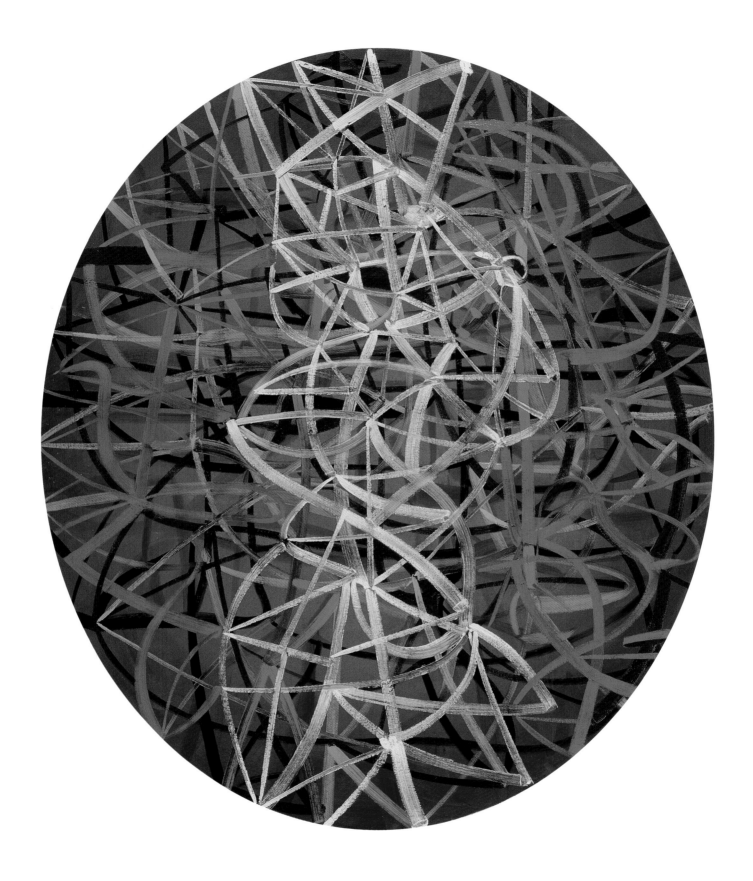

94 *Ignis*, 1998, oil on canvas, 206 × 174 cm, Helmut Pabst, Frankfurt

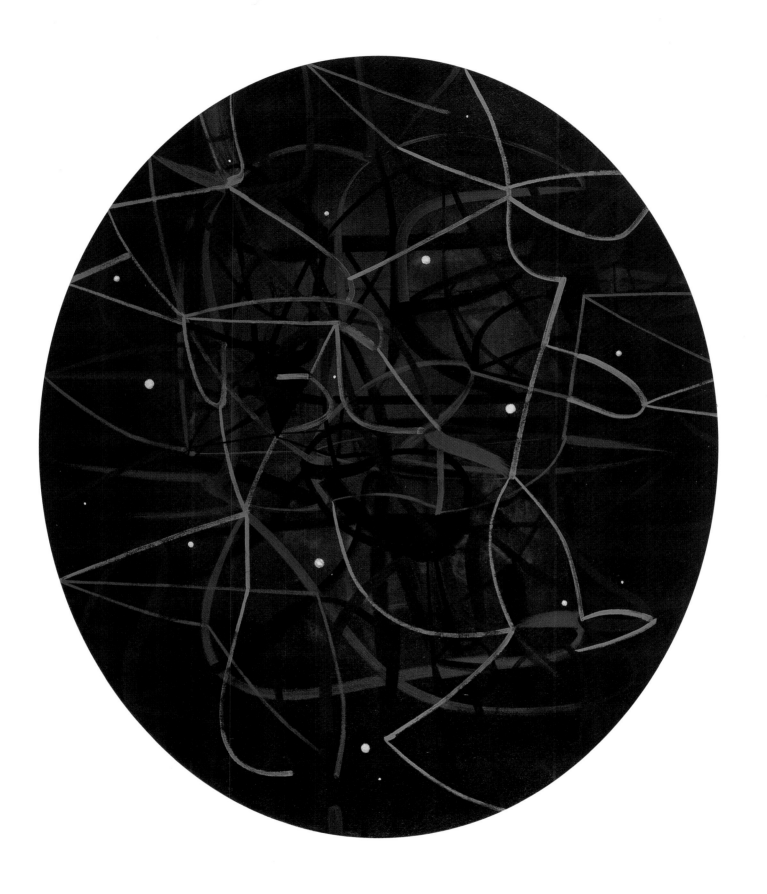

Aer, 1998, oil on canvas, 206 × 174 cm, Helmut Pabst, Frankfurt

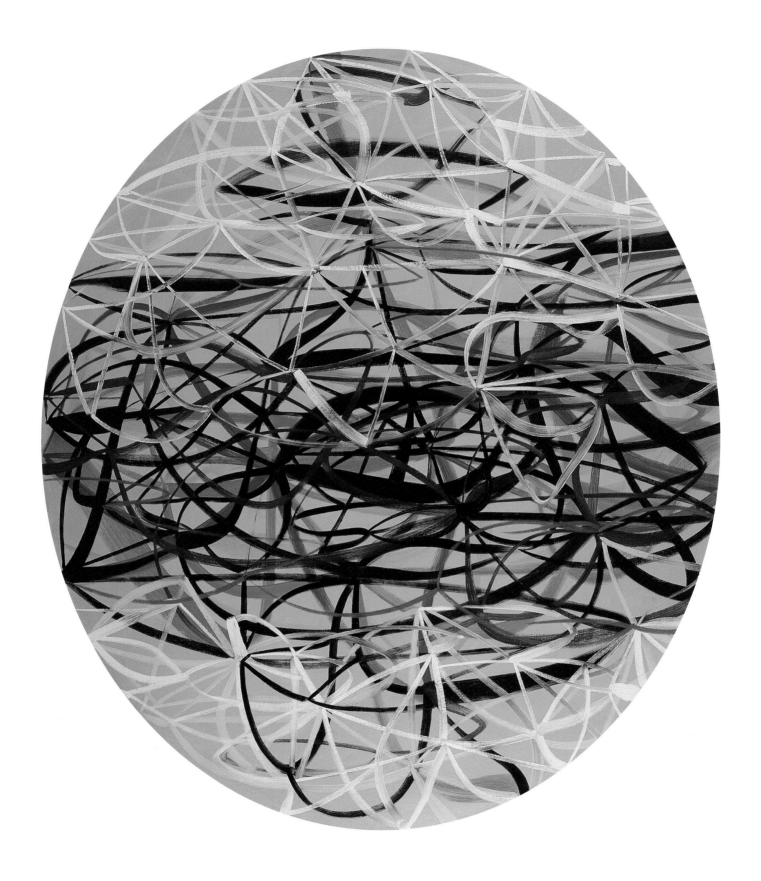

Aqua, 1998, oil on canvas, 206 × 174 cm, Helmut Pabst, Frankfurt

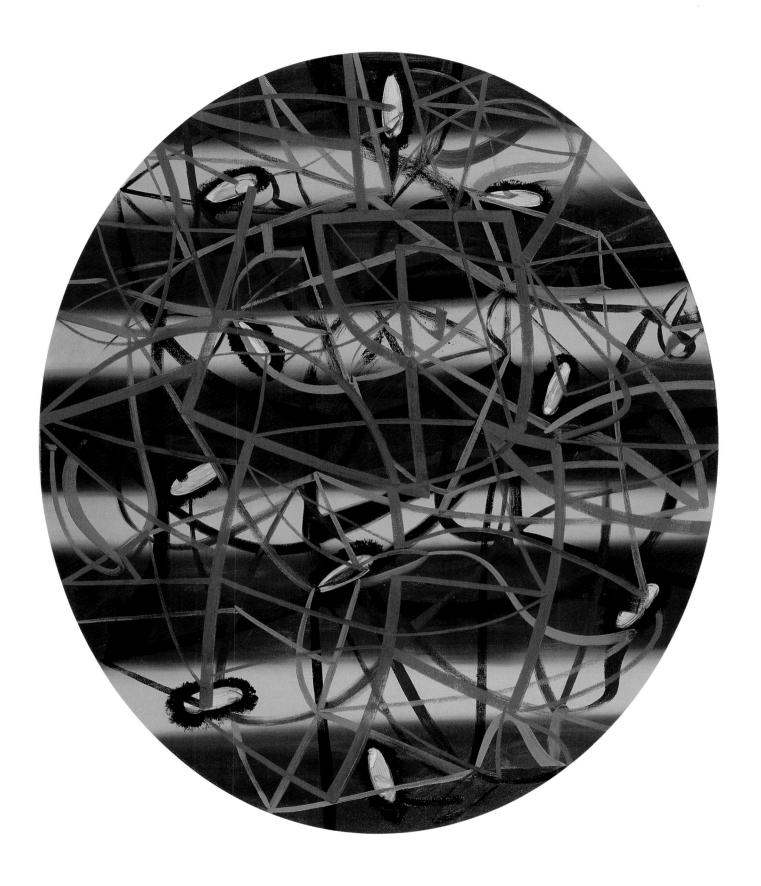

Terra, 1998, oil on canvas, 206 × 174 cm, Helmut Pabst, Frankfurt

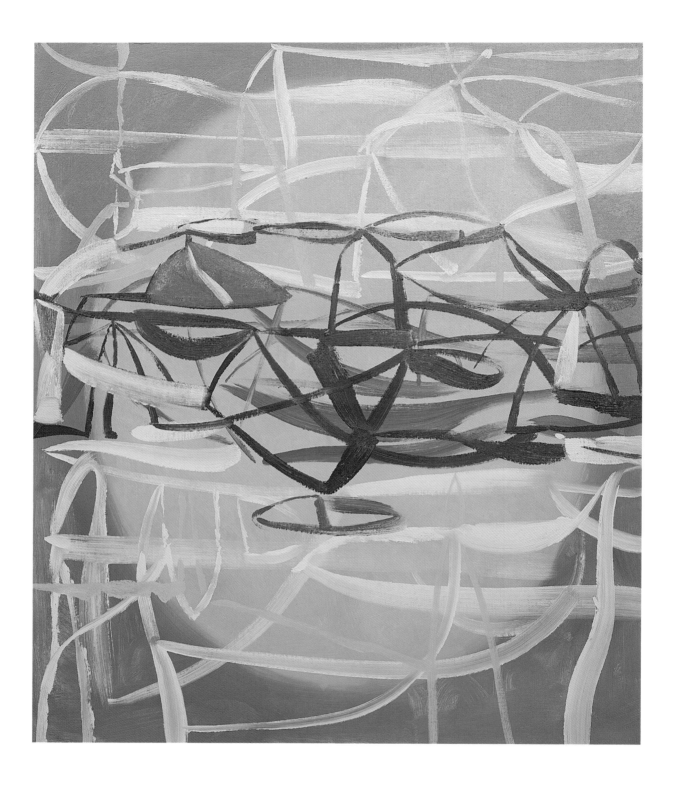

Water Version 1, 1997, oil on linen, 127 × 106.5 cm, courtesy of the artist

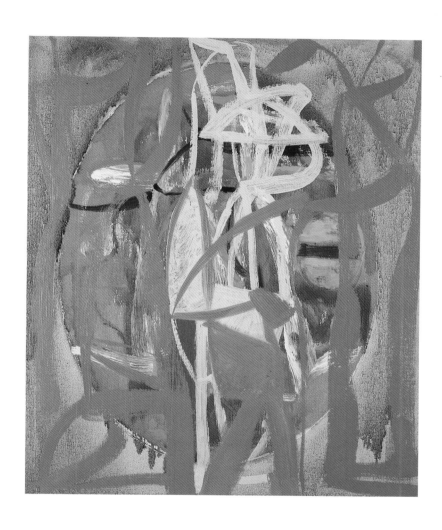

Fire Version 2, 1997–98, oil on linen, 60 × 50 cm, collection of DZ Bank, London

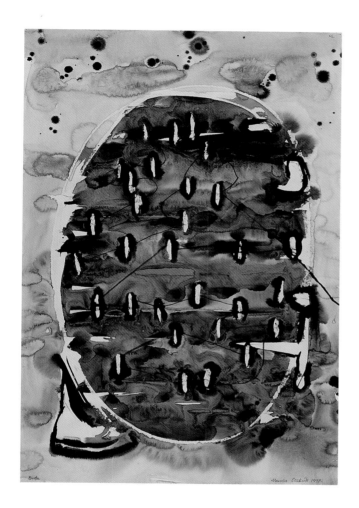
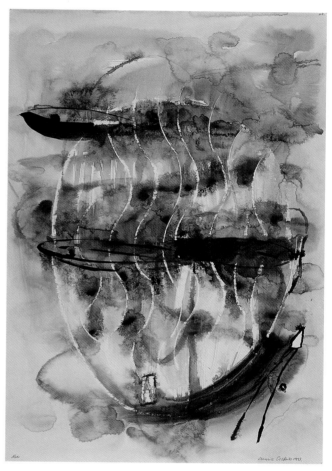

Studies for 'Elements', from a series of 50, 1998, watercolour, pencil, wax on paper, 84 × 57 cm,
courtesy of the artist and Galerie Bugdahn und Kaimer, Düsseldorf

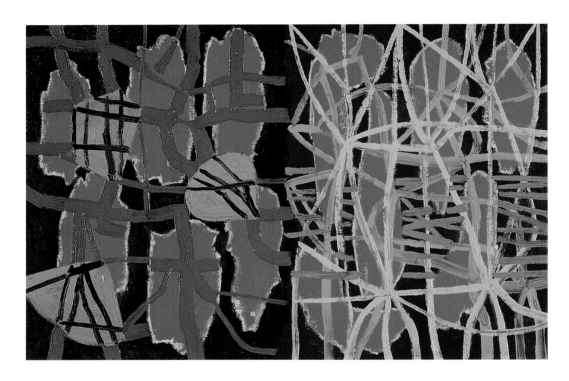

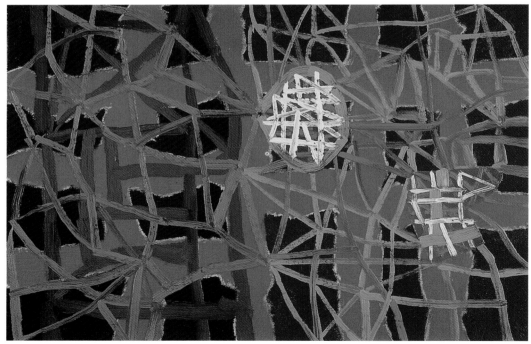

Divided (untitled) **A**, 1999, oil on linen, 40 × 60 cm, courtesy of the artist

Divided (untitled) **B**, 1999, oil on linen, 40 × 60 cm, courtesy of the artist

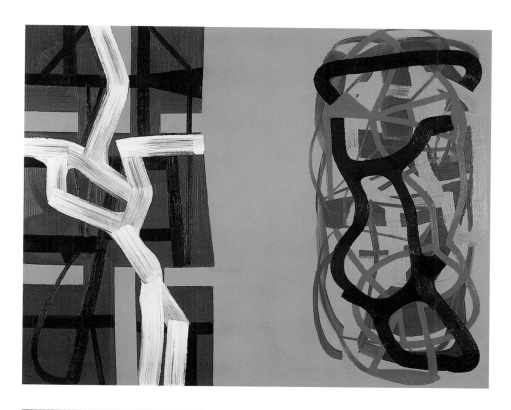

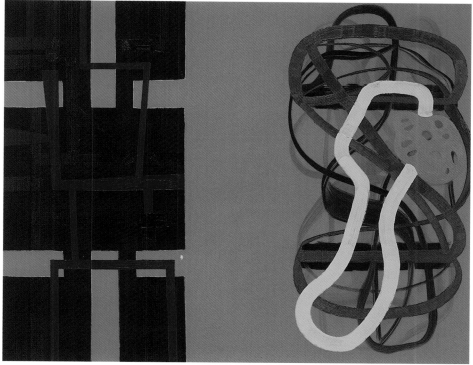

Divided (untitled) **C**, 2000, oil on linen, 80 × 100 cm, 2000, Galerie Bugdahn und Kaimer, Düsseldorf

Divided (untitled) **D**, 2000, oil on linen, 80 × 100 cm, 2000, Galerie Bugdahn und Kaimer, Düsseldorf

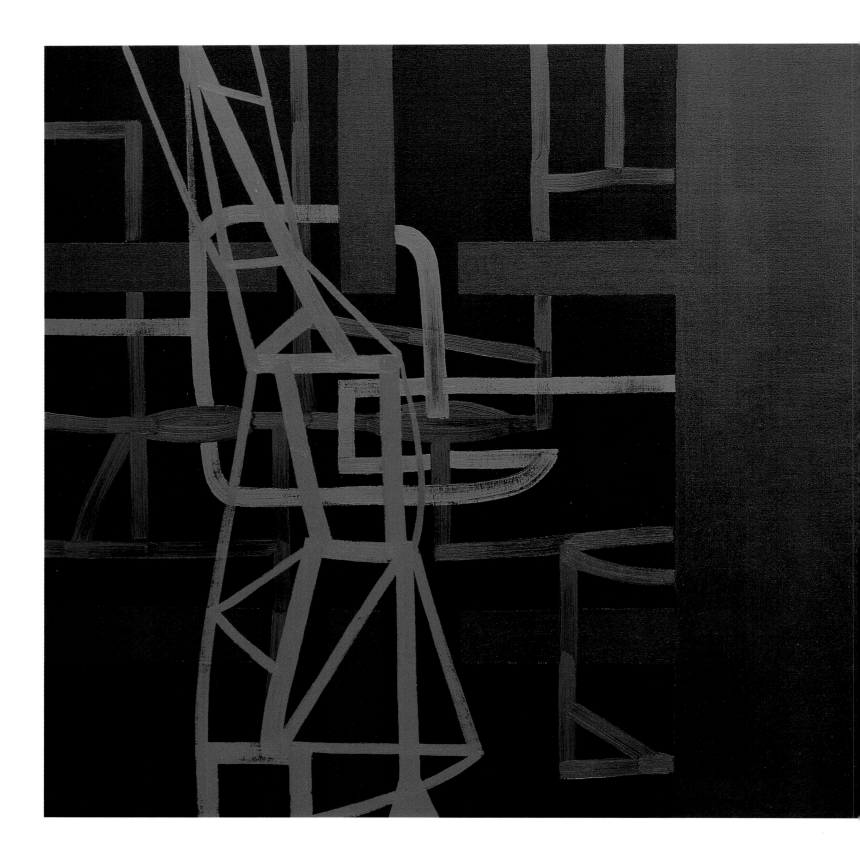

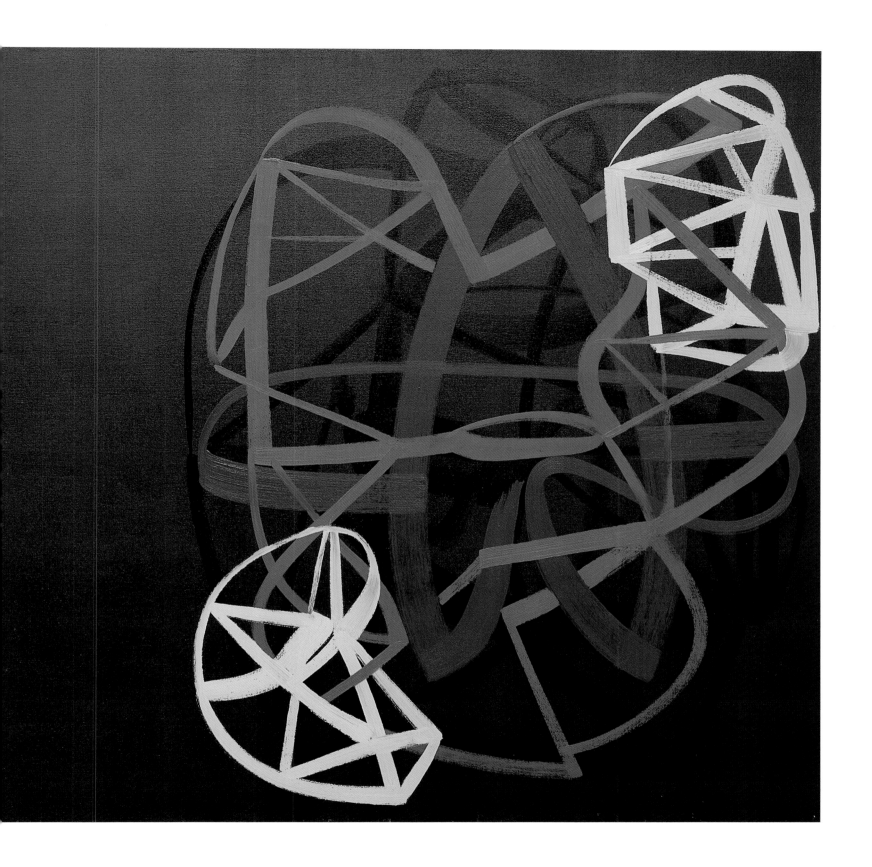

Divided #39, 1999, oil on canvas, 120 × 250 cm, courtesy of the artist

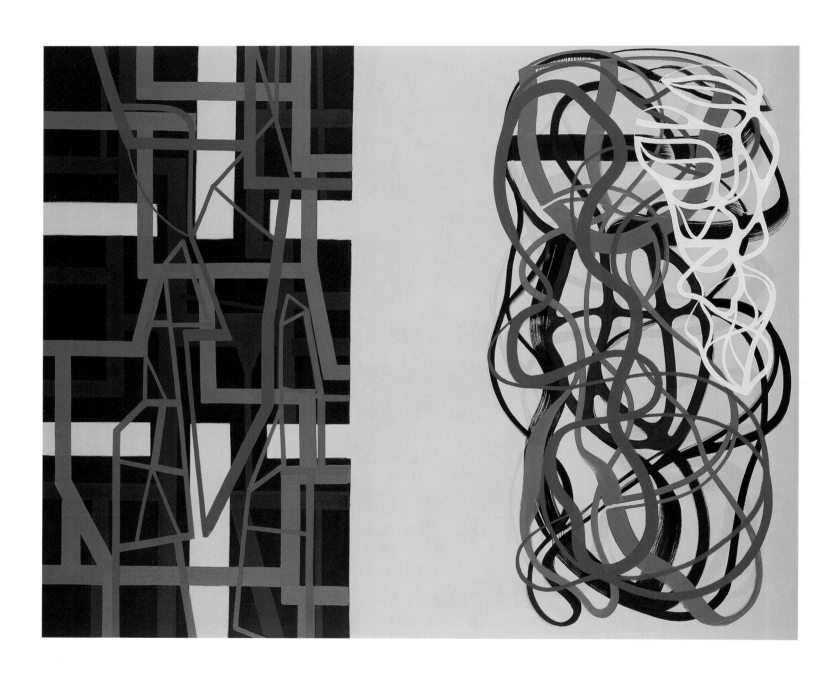

Divided #84, 2000, oil on canvas, 240 × 300 cm, Royal Academy of Arts, London

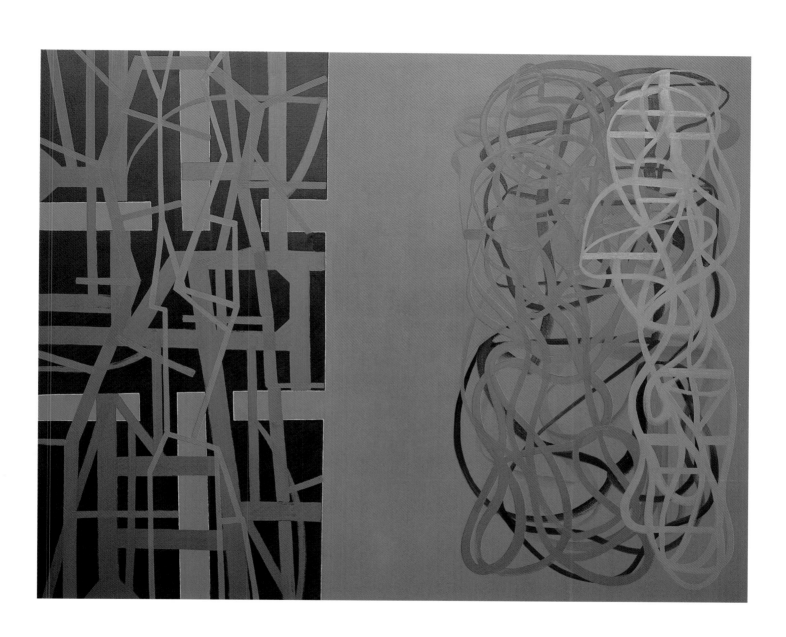

Divided #72, 2000, oil on linen, 160 × 200 cm, courtesy of the artist

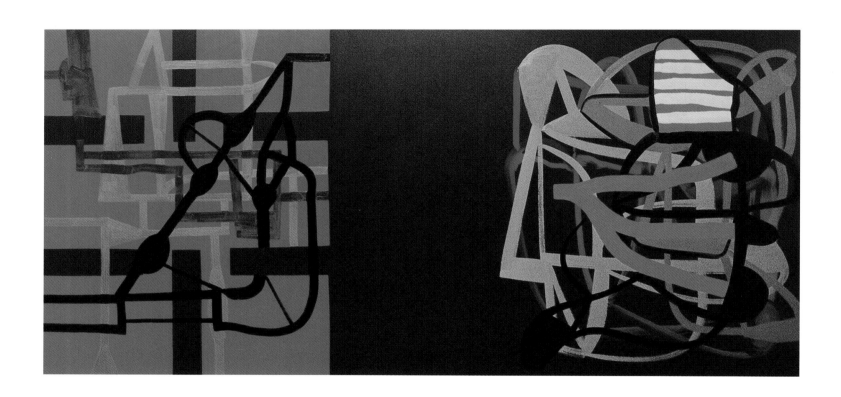

Divided #48, 2000, oil on canvas, 120 × 250 cm, private collection, Switzerland

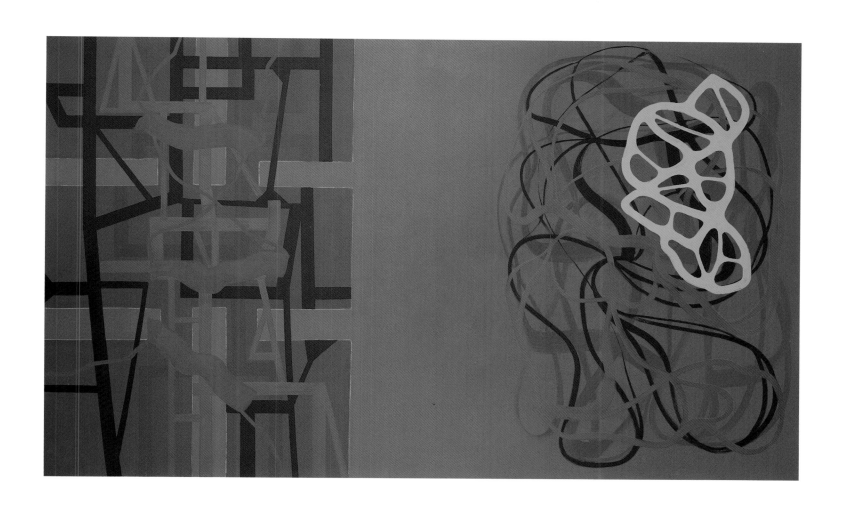

Divided #83, 2000, oil on canvas, 180 × 300 cm, courtesy of the artist

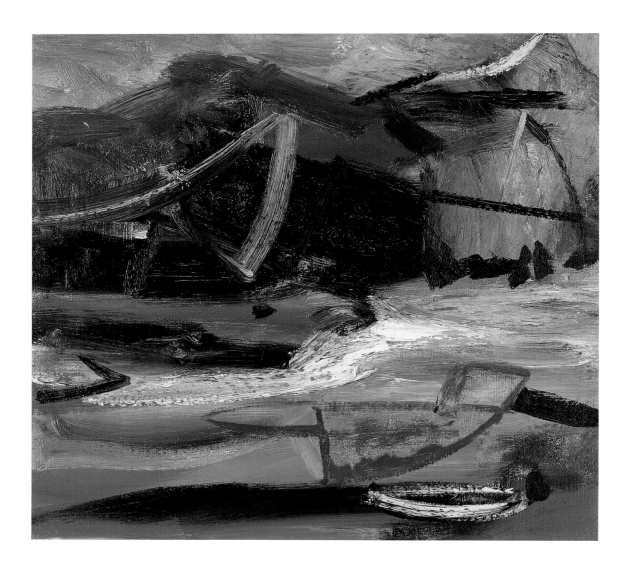

Sloop, from '**Conwy River Cycle'**, 1998, oil on linen, 60 × 65 cm, collection of Pauline and Ray Treen, London

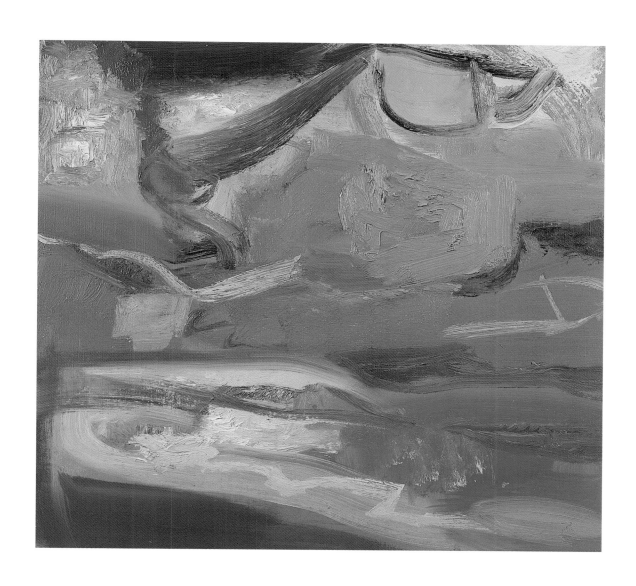

Ochre Machine from **'Conwy River Cycle'**, 1998, oil on canvas, 60 × 65 cm, Belgrave Gallery, London

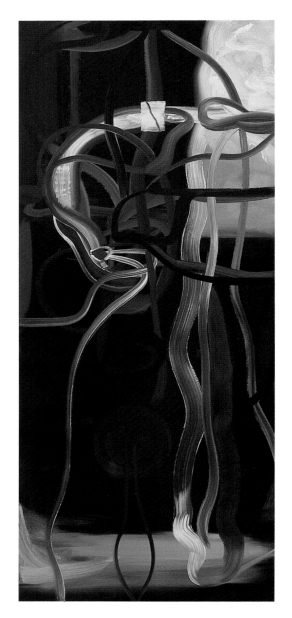
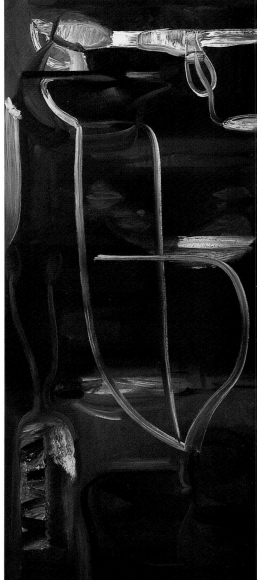

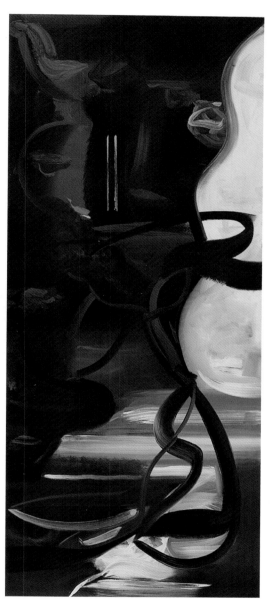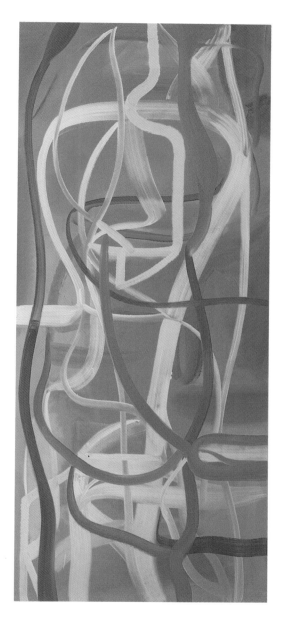

'Afon Cycle', 2000, oil on canvas, 5 panels, each 210 × 90 cm, courtesy of the artist

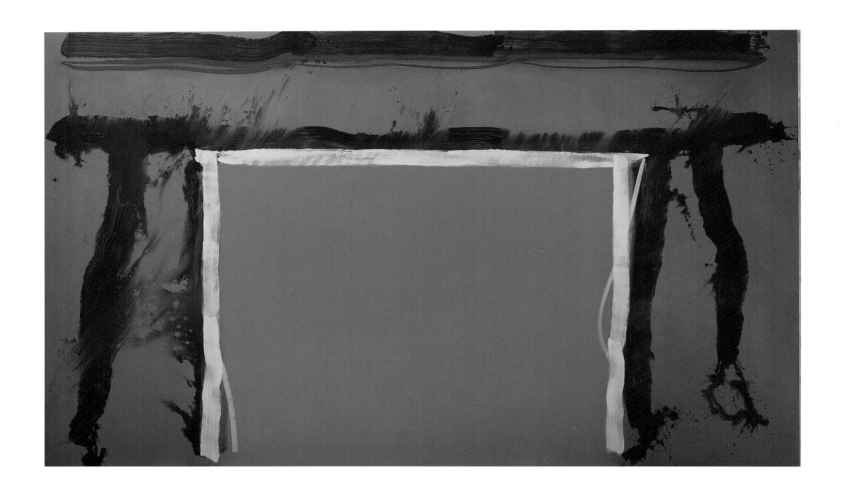

***Bridge #1**, 2001, oil and acrylic on canvas, 180 × 300 cm, collection of Nigel Slydell*

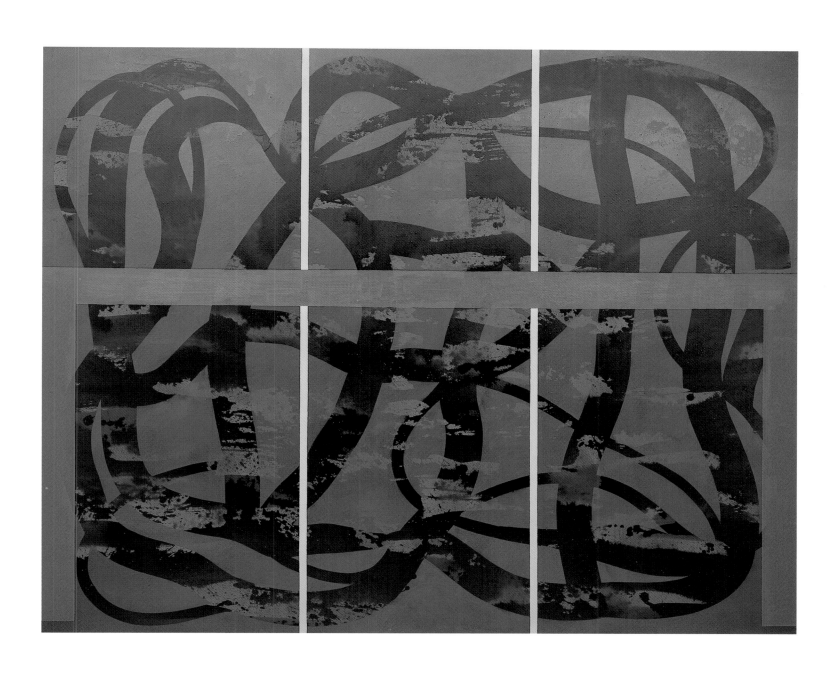

Primaries Bridge, 2002, oil and acrylic on canvas, 200 × 250 cm, courtesy of the artist

Gilded Bridge in Blue, 2002, oil and acrylic on canvas, 150 × 180 cm, courtesy of the artist

***Echo Bridge**, 2002, oil and acrylic on canvas, 200 × 250 cm, courtesy of the artist*

Scarlet Dancing, 2002, oil and acrylic on canvas, 200 × 250 cm, courtesy of the artist

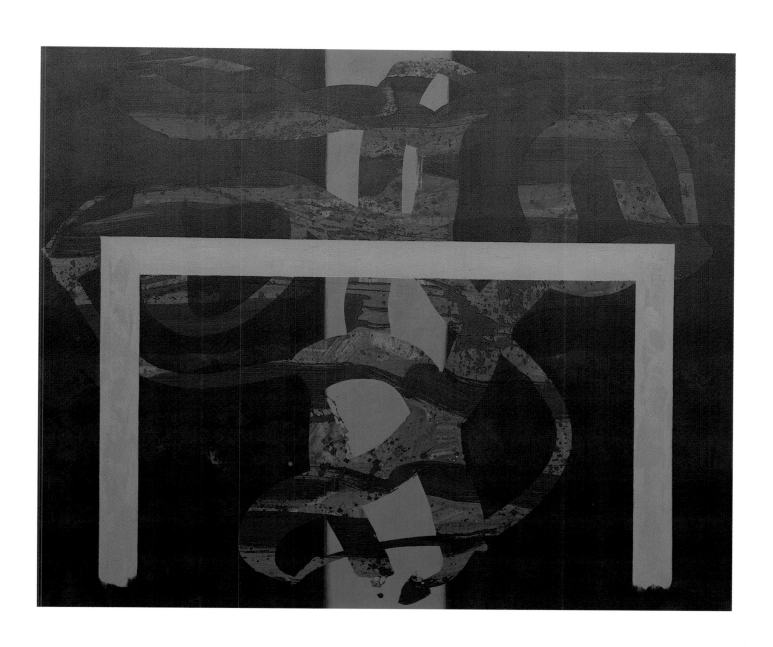

Blue Fire Bridge, 2002, oil and acrylic on canvas, 150 × 180 cm, courtesy of the artist

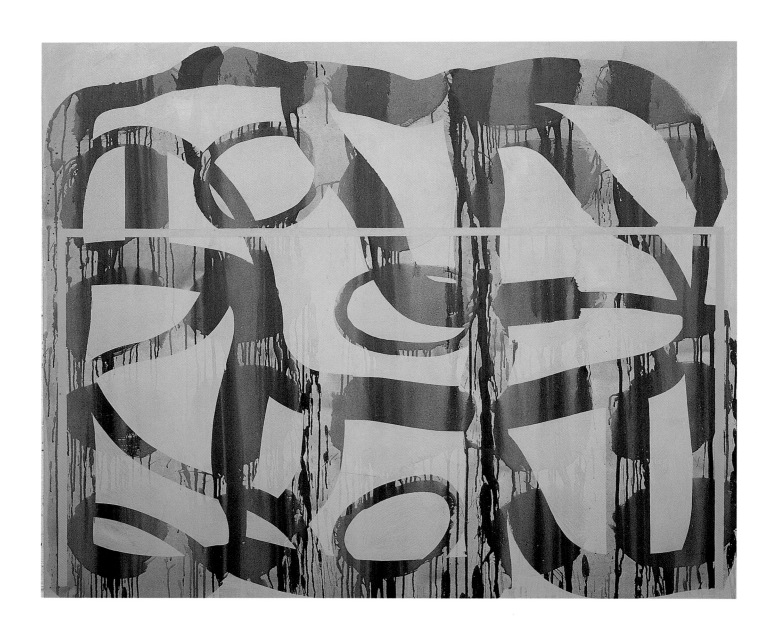

Little Bridge of Pale Orange, 2002, oil and acrylic on canvas, 150 × 180 cm, courtesy of the artist

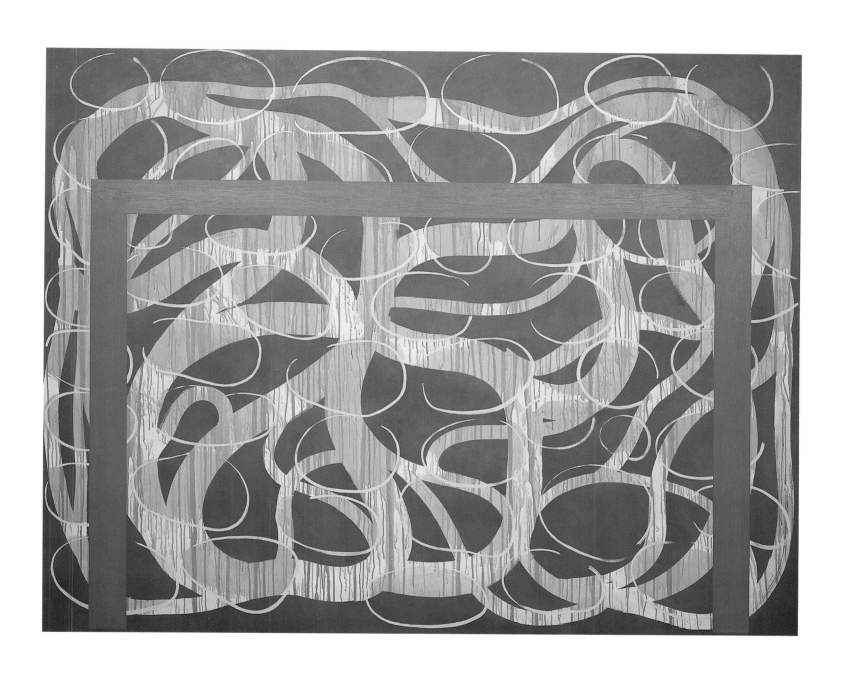

Roman Bridge, 2002, oil and acrylic on canvas, 200 × 250 cm, courtesy of the artist

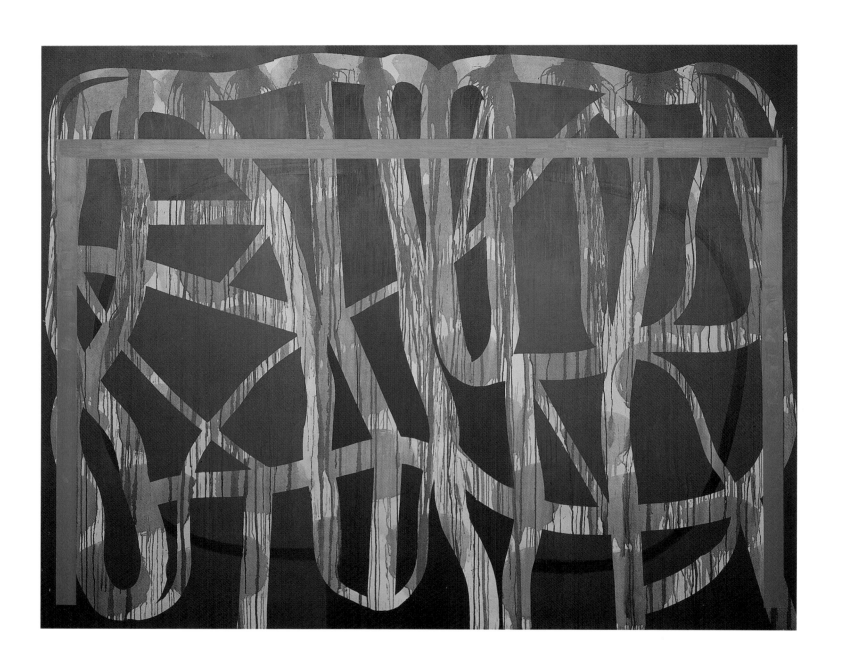

Celtic Bridge, 2002, oil and acrylic on canvas, 240 × 300 cm, courtesy of the artist

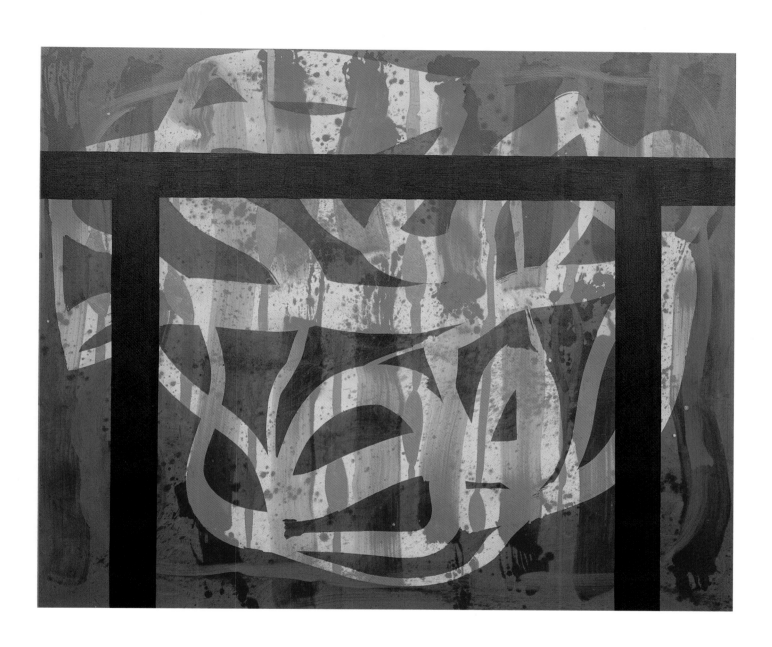

Gold Fire Bridge, 2002, oil and acrylic on canvas, 150 × 180 cm, courtesy of the artist

BIOGRAPHICAL SUMMARY

1936 Born 8 October, Hartlepool.

1938–42 Moves with family to South Wales, then a peripatetic existence in Wales and the Midlands.

1942–60 Growing up in North Wales, near Wrexham. His son Steven born 1958. Begins full-time study at Wrexham School of Art, 1960.

1961–64 Studying fine art at the University of Reading. His son Joel born 1964.

1964–66 Moves to Liverpool. Teaches at St Helen's School of Art.

1967 Begins teaching in the Faculty of Art, Liverpool Polytechnic. His first major group exhibition, *Art in a City*, at the Institute of Contemporary Arts, London.

1970–71 Beginning of his photorealist period. First major one-man exhibition, at the Serpentine Gallery, London. Visits Spain.

1973 Shows *Two Windows, Two People* at the Liverpool Academy exhibition, *Communication*, at the Walker Art Gallery, Liverpool.

1974 First appearance in the John Moores exhibition at the Walker Art Gallery, Liverpool: *Scillonian Pumps* wins a £100 prize in John Moores 9. Shows at the Bluecoat Gallery, Liverpool. *Sudley* and *The Walker Art Gallery* commissioned by the Friends of Merseyside Museums and Art Galleries.

1975 Commissioned to paint *Entrance* by the University of Liverpool. Visits Holland, Belgium and Germany.

1976 *Northwest Passage* shown in the Liverpool Academy *Face of Merseyside* exhibition (Walker Art Gallery, Liverpool, and tour); *Sailing on for Toots* shown in John Moores 10.

1977 Four photorealist works exhibited in *Peter Moores Liverpool Project 4: Real Life* at the Walker Art Gallery, Liverpool.

1978 Receives Arts Council commission for *Seven in Two* project, Lime Street Station, Liverpool. Four-month study trip to America. On return, moves from Aigburth to Bridewell Studios.

1979 *Seven in Two* installed in Lime Street Station, Liverpool, in October. Drawings exhibited concurrently at the Bluecoat Gallery, Liverpool.

1980 One-man exhibition of still lifes and nocturnes at the Bluecoat Gallery, Liverpool. Leaves full-time teaching.

1981 Extended visit to Italy.

1982 One-man show at the Bluecoat Gallery, Liverpool, includes drawings in tempera and pastel, among them *The Warrior* and *Winged Maiden. At the Frontier* shown in John Moores 13. Moves to London and takes a studio in Berry Street, Clerkenwell.

1982–85 Occasional visiting tutor at schools of art in Manchester, Portsmouth, Farnham, Winchester and Nottingham.

1983 First group show at Edward Totah Gallery, London.

1984 One-man exhibition at University of Nottingham Art Gallery, subsequently shown at Edward Totah Gallery, London, includes *The Accusation, Times of Day, Judith.* Moves to new studio in West Norwood. Begins part-time teaching at St Martin's School of Art, London.

1985 One-man show, *Heroes and Victims*, at Kunstmuseum Düsseldorf. Visiting tutor at the Royal College of Art, London, and Central School of Art, London (until 1988).

1986 One-man show, *Venus and Mars*, at Galerie Bugdahn und Szeimies, Düsseldorf.

1987 First one-man show at Bernard Jacobson Gallery, London. *Venus and Mars: In the Heat* shown at John Moores 15.

1988 One-man show at Bernard Jacobson Gallery, New York, includes *The Third* and other figure paintings of 1986–87. *Yield* is shown in *Mother and Child* group show at The Lefevre Gallery, London.

1989 His son William born.

1990 One-man show, *Song of the Earth*, at Bernard Jacobson Gallery, London. Paints the 'Four Seasons' series.

1991 Moves studio to Cambridge Gate, Regent's Park, London.

1992 'Four Seasons' and 'Entrances' exhibited in one-man show at Bernard Jacobson Gallery, London: the former purchased by the Walker Art Gallery, Liverpool; the latter tours to three venues in the west of England.

1993 'Wheat' series exhibited at Galerie Bugdahn und Kaimer, Düsseldorf. Moves studio to the Diorama, Regent's Park. Innisfree watercolours exhibited at Bernard Jacobson Gallery, London.

1994 One-man show, *Generation*, at Bernard Jacobson Gallery, London. Nominated for the Jerwood Prize and included in Jerwood exhibitions at the Royal Scottish Academy, Edinburgh, and the Royal Academy of Arts, London. Moves to West Dulwich studio, south-east London. Solo exhibitions at Galerie Helmut Pabst, Frankfurt, and Galerie Molinaars, Breda, The Netherlands.

1995 Artist in Residence at the College of Fine Arts, University of New South Wales. Paints at Blue Mountains, visits Queensland and Hong Kong. Solo exhibition at Galerie Helmut Pabst, Frankfurt. Major retrospective, 1974–94, at the Walker Art Gallery, Liverpool; tours to Djanogly Art Gallery, University of Nottingham, and Cleveland Gallery, Middlesbrough. Shows 'Place of Fire' series at Bernard Jacobson Gallery, London, and 'Ash' series at Galerie Clivages, Paris. One-man show at Annandale Galleries, Sydney.

1995–98 Visiting tutor at the Royal Academy Schools, London.

1996 'A Portable Kingdom' series exhibited at Bernard Jacobson Gallery, London. Ceases affiliation to Bernard Jacobson Gallery.

1997 Begins staying and working intermittently at Bryn Eisteddfod studio, North Wales. Shows 'A Portable Kingdom' in Frankfurt and Paris. Retrospective of works on paper at Belgrave Gallery, London.

1998	Produces 'Anthology' suite of aquatints at Stoneman Graphics, Cornwall, published by Helmut Pabst. Retrospective at Royal West of England Academy, Bristol, including 'Elements' and 'Dilation' series. Solo exhibitions at Purdy Hicks Gallery, London; Galerie le Triangle Bleu, Stavelot, Belgium; Galerie Helmut Pabst, Frankfurt; Galerie Bugdahn und Kaimer, Düsseldorf; shows 'Conwy River Cycle' at Ogilvy and Estill Gallery, Conwy, North Wales.	

1998 Produces 'Anthology' suite of aquatints at Stoneman Graphics, Cornwall, published by Helmut Pabst. Retrospective at Royal West of England Academy, Bristol, including 'Elements' and 'Dilation' series. Solo exhibitions at Purdy Hicks Gallery, London; Galerie le Triangle Bleu, Stavelot, Belgium; Galerie Helmut Pabst, Frankfurt; Galerie Bugdahn und Kaimer, Düsseldorf; shows 'Conwy River Cycle' at Ogilvy and Estill Gallery, Conwy, North Wales.

1999 Elected to the Royal Academy of Arts, London. Solo exhibition at Annandale Galleries, Sydney.

2000 Solo exhibition at Galerie Vidal-Saint Phalle, Paris. 'Divided' series shown at Galerie Bugdahn und Kaimer, Düsseldorf.

2001 'Elements' and related works shown at Galerie Helmut Pabst, Frankfurt; 'Spectral Rivers' series exhibited at the Royal Academy of Arts, London.

2002 'Bridge' series ongoing at West Dulwich studio.

Solo Exhibitions

1971 Serpentine Gallery, London
Peterloo Gallery, Manchester

1974 Bluecoat Gallery, Liverpool

1976 *Paintings and Drawings*, Liverpool Academy Gallery

1979 *Seven in Two*, Bluecoat Gallery, Liverpool
St Paul's Gallery, Leeds

1979–80 *Seven in Two*, Lime Street Station, Liverpool

1980 Bluecoat Gallery, Liverpool

1981 Festival Commission, Milton Keynes

1982 Bluecoat Gallery, Liverpool

1984 University of Nottingham Art Gallery
Edward Totah Gallery, London

1985 Edward Totah Gallery, London
Heroes and Victims, Kunstmuseum Düsseldorf

1986 *Venus and Mars*, Galerie Bugdahn und Szeimies, Düsseldorf

1987–90 Bernard Jacobson Gallery, London

1988 Bernard Jacobson Gallery, New York

1992 Bernard Jacobson Gallery, London
Newlyn Art Gallery, Penzance
Spacex Gallery, Exeter
Plymouth Art Centre, Plymouth

1993 *Wheat*, Galerie Bugdahn und Kaimer, Düsseldorf

1994 *Generation*, Bernard Jacobson Gallery, London
Galerie Helmut Pabst, Frankfurt
Works on Paper, Galerie Molinaars, Breda, The Netherlands

1995 Galerie Helmut Pabst, Frankfurt
Retrospective, 1974–94, Walker Art Gallery, Liverpool, touring: Djanogly Art Gallery, University of Nottingham, and Cleveland Gallery, Middlesbrough
Place of Fire, Bernard Jacobson Gallery, London
The Ash Series, Galerie Clivages, Paris
Annandale Galleries, Sydney

1996 *Drawings*, Annandale Galleries, Sydney
A Portable Kingdom, Bernard Jacobson Gallery, London

1997 Galerie Clivages, Paris
Galerie Helmut Pabst, Frankfurt
Works on Paper, Belgrave Gallery, London

1998 Retrospective, Royal West of England Academy, Bristol
Elements, Purdy Hicks Gallery, London, touring: Galerie Helmut Pabst, Frankfurt, and Galerie Bugdahn und Kaimer, Düsseldorf
Galerie le Triangle Bleu, Stavelot, Belgium
Conwy River Cycle, Ogilvy and Estill Gallery, Conwy, North Wales

1999 Annandale Galleries, Sydney

2000 Galerie Vidal-Saint Phalle, Paris
Galerie Bugdahn und Kaimer, Düsseldorf

2001 Galerie Helmut Pabst, Frankfurt

2002 Archeus Fine Art, London

Selected Group Exhibitions

1967 *Art in a City*, Institute of Contemporary Arts, London

1968 *Poets' Choice*, Association of International Artists Gallery, London

1971 *Spectrum North*, Arts Council of Great Britain, touring: Leeds City Art Gallery; Laing Art Gallery, Newcastle; Manchester City Art Gallery
Bluecoat Gallery, Liverpool
Now, Arts Council of Wales tour

1972 *Every Picture Tells*, Welsh Arts Council tour

1973 Eisteddfod Festival, Wales (prize-winner)
Communication, Walker Art Gallery, Liverpool

1974 John Moores 9 (prize-winner)
Industrial Sponsors Exhibition, Grosvenor House, London
Aspects of Realism, Sunderland Arts Centre, Tyne and Wear

1975 *Reality, Fantasy, Illusion*, Rochdale Art Gallery, Lancashire
Liverpool Academy at the Third Eye Centre, Glasgow

1976 *Face of Merseyside*, Walker Art Gallery, Liverpool
John Moores 10

1977 *Peter Moores Liverpool Project 4: Real Life* at the Walker Art Gallery, Liverpool.
Arts Council Collection 1976–77, Hayward Gallery, London

1979 *Recent Purchases*, University of Liverpool, Senate House

1980 University of Nottingham Art Gallery

1981 Cleveland International Drawing Biennale

1982 *British Drawing*, Hayward Gallery Annual, London
Fruitmarket Gallery, Edinburgh

1982–83 John Moores 13

1983 Edward Totah Gallery, London
Tolly Cobbold 4th National Exhibition, Barbican Art Gallery, London

1984 *Capital Painting*, Barbican Art Gallery, London
Royal Academy Summer Exhibition 216, London

1985 Edward Totah Gallery, London
Hommage aux Femmes, ICC Galerie, Berlin, touring: Municipal Museum, Leverkusen
Athena Art Awards, Barbican Art Gallery, London
John Moores 14

1987 John Moores 15

1988 *Mother and Child*, The Lefevre Gallery, London

1989 *Recent Paintings*, Bernard Jacobson Gallery, London
Salute to Turner, Agnew's, London

1990–91 *Forces of Nature*, Manchester City Art Gallery, touring: Harris Museum, Preston

1991 *Works on Paper*, Galerie Molinaars, Breda, The Netherlands

1991–92 *Cabinet Paintings*, Gillian Jason Gallery, London, touring: Cyril Gerber Fine Art, Glasgow; Hove Museum and Art Gallery; Glynn Vivian Art Gallery, Swansea

1992 *The Figure Laid Bare*, Pomeroy Purdy Gallery, London
1993 *Works on Paper II*, Bernard Jacobson Gallery, London
1994 Jerwood Prize exhibition, Royal Scottish Academy, Edinburgh, and Royal Academy of Arts, London
1994–95 *An American Passion*, McLellan Galleries, Glasgow, and the Royal College of Art, London
1995 *Painting*, Galerie Bugdahn und Kaimer, Düsseldorf
 Paintscapes, Harewood House, Yorkshire
1996 *Natural Forces*, Reeds Wharf Gallery, London
 Black Grey White, Galerie Bugdahn und Kaimer, Düsseldorf
1997 Guest artist, Florence Trust, London
 The Enduring Tradition, Tamworth City Art Gallery, New South Wales
1998 *Drawings*, Cairns Regional Art Gallery, New South Wales, touring
1999 Purdy Hicks Gallery, London
 Annandale Galleries, Sydney
 Art fairs, Berlin and Cologne
 Royal Academy of Arts, London

2000 Royal Academy of Arts, London
 Afon, Oriel Mostyn Art Gallery, Llandudno, North Wales
 Galerie Vidal-Saint Phalle, Paris (four artists)
 Universitaire Moretus Plantin, Namur, Belgium
2001 *Works on Paper*, Musée des Beaux-Arts de Tourcoing
 Summer Exhibition 233, Royal Academy of Arts, London

Awards

1977 Arts Council of Great Britain, Flags and other Projects (prize-winner), Royal Festival Hall, London
1977–78 Arts Council of Great Britain major award. Extended visit to the United States
1978–79 Arts Council of Great Britain, Works of Art in Public Spaces
1985 British Council award

Television

1976 *Arena*, October, BBC2
1981 *Celebration*, March, Granada Television
1999 *Afon*, August, Harlech Television

Collections

Arts Council Collection, Hayward Galley, London
Atkinson Art Gallery, Southport
Borough of Milton Keynes
The British Museum, London
Centro Cultural Arte Contemporaneo, Polanco, Mexico
Contemporary Art Society
Contemporary Art Society for Wales
Deutsche Bank
DZ Bank, London
Granada Television
Hertfordshire Education Committee
Alexander Howden Group
Kunstmuseum Düsseldorf
The Leicester Collection
Liverpool Daily Post
London Borough of Camden
Riggs Bank N.A., London
Royal Academy of Arts, London
Ulster Museum, Belfast
Unilever PLC, London
University of Liverpool
Walker Art Gallery, Liverpool (National Museums & Galleries on Merseyside)
Arts Council of Wales

SELECTED BIBLIOGRAPHY

Exhibition Catalogues

Maurice Cockrill: Recent Works, exhib. cat. by Marco Livingstone, Liverpool, Bluecoat Gallery, 1980
Maurice Cockrill: Paintings 1982–83, exhib. cat. by Nicholas Alfrey, Nottingham, University Art Gallery; London, Edward Totah Gallery, 1984
Maurice Cockrill: Helden und Opfer (Heroes and Victims), exhib. cat. by Hans Albert Peters, Düsseldorf, Kunstmuseum, 1985
Maurice Cockrill: Venus and Mars, exhib. cat. by Alistair Hicks and Marco Livingstone, Düsseldorf, Galerie Bugdahn and Szeimies, 1986
Maurice Cockrill: Song of the Earth, exhib. cat. by Nicholas Alfrey and David Cohen, London, Bernard Jacobson Gallery, 1990
Maurice Cockrill: Generation, exhib. cat. by Richard Mabey, includes revised version of 'Fragments of an Autobiography' (see Drabble 1992, below), London, Bernard Jacobson Gallery, 1994

(Richard Mabey's essay is reprinted in Richard Mabey, *Selected Writings 1974–1999*, London 1999, pp. 232–37)
Maurice Cockrill: Paintings and Drawings 1974–1994, exhib. cat. by Nicholas Alfrey and Alex Kidson, Liverpool, Nottingham and Middlesbrough, 1995
Maurice Cockrill: Place of Fire, Ash, A Portable Kingdom, exhib. cat. by Nicholas Alfrey, London, Bernard Jacobson Gallery, 1996
Maurice Cockrill, exhib. cat. by Ann Elliott, Bristol, London, Düsseldorf and Frankfurt, 1998

Print Edition

Anthology, a suite of aquatints, introductory essay by Norbert Lynton, Düsseldorf 1999

Monograph

Margaret Drabble, *Maurice Cockrill*, Modern British Masters v, London 1992. Includes first version of 'Fragments of an Autobiography'

General Surveys

Alistair Hicks, *The School of London: The Resurgence of Contemporary Painting*, Oxford 1989
Peter Davies, *Liverpool Seen: Post-War Artists on Merseyside*, Bristol 1992
Mary Findlay, Alistair Hicks and Friedhelm Hütte (eds.), *Art Works: British and German Contemporary Art 1960–2000*, London 2001

Periodicals

David Cohen, 'Maurice Cockrill: Song of the Earth', *Modern Painters*, iii, no. 1, 1990, pp. 85–86
Margaret Drabble, 'Maurice Cockrill's Seasons', *Modern Painters*, v, no. 1, 1992, pp. 20–23
Interview with Maurice Cockrill, *Clivages*, bulletin no. 4, 1995, unpaginated
Norbert Lynton, 'Maurice Cockrill: The Journey to a Portable Kingdom', *Contemporary Art*, issue 13, 1996, pp. 8–16